Wicked RICHMOND

Wicked
RICHMOND

Many thanks!

B Brown

10/2010

BETH BROWN

Charleston | London

THE
History
PRESS

Published by The History Press
Charleston, SC 29403
www.historypress.net

First published 2010

Manufactured in the United States

ISBN 978.1.59629.869.9

Brown, Beth, 1977-
Wicked Richmond / Beth Brown.
p. cm.
Includes bibliographical references.
ISBN 978-1-59629-869-9
1. Richmond (Va.)--History--Anecdotes. 2. Richmond (Va.)--Biography. I. Title.
F234.R557B76 2010
975.5'451--dc22
2010031406

This book is dedicated to my grandmother, Doodley. Her kitchen table stories of the old wooden Manchester Bridge, grisly injuries caused by streetcars and the death of her cousin, William, at the hands of gangsters Mais and Legenza taught me to truly appreciate the peculiarities of Richmond. For that, I will be forever grateful.

Contents

CONTENTS

Introduction

The recipe for what creates the personality of a city is seldom found in history texts alone, those volumes that so lovingly praise a locale's great achievements. Much like a person, a city is molded from its management of hardship, confrontation and inner struggle, all things from which it learns how to grow and prosper. Richmond, Virginia, is no different.

Human nature is such that we are fascinated, sometimes even consumed, by bad people doing bad things. That said, these tales of treachery, murder and more—the ugliest skeletons in the city's closet—need little introduction. The events I have chosen to share in this book are a collection of Richmond's obstacles, both internal and external. Residents in the past have passed notes about these calamities, whispered about them over back fences or phoned someone "in the know" to find out the latest developments. There were few happy endings in these types of stories, but the people of Richmond enjoyed hanging on for every detail. I hope you will do the same.

Lust, Lost Fortune and the Lottery

When English adventurers first set foot on Virginia soil in 1607, they had high hopes that life and agriculture in this new wilderness would be an answer to their prayers. Winter came much too soon for the settlement, though, and it turned out to be more severe than any they had previously endured in the old country. Conflicts with the native peoples were constant and proved to be part of the new way of life for settlers and added to their struggle for survival.

Despite these new hardships, many survived, growing tougher and more determined with each passing year. The settlement at Jamestown grew, and more opportunists arrived by the shipload with one prize on their minds—tobacco. Virginia proved to be a perfect environment for *Nicotiana tabacum*. The plant was such an important crop for the early colony that it was considered a form of currency for well over two hundred years. More and more farmland was cut from the forests along the banks of the Powhatan River, called the James River by colonists, so that the English tobacco fields spanned from the Chesapeake Bay to the area where Powhatan, chief of an Algonquin tribe, made his seat of power, just east of the fall line.

In 1737, William Byrd II determined that a city at the falls would be ideal. After an extensive survey of the area, he returned home to his plantation at Westover and began laying out a plan. Byrd, having been educated in England, dubbed the town Richmond because of the

similarities in the view of the James River from atop Indian Hill (now Church Hill) and the view of the Thames from Richmond, England.

Progress on Byrd's plan was swift, and Richmond was chartered as a town in 1742.

From the very beginning, at the time of the founding of the city itself, a wicked shadow was cast on Richmond by its paternal planner. Though Byrd was a very capable surveyor, his reputation as a lusty socialite preceded him wherever he went. A gentleman of one of the First Families of Virginia, he was held to a high moral standard and a set of particular social expectancies, none of which he chose to honor.

In his once secret diaries, published in 1940, Byrd kept intricate records of the events in his daily life—especially his sexual exploits. While married to his first wife, Lucy Parke, William II details in his journal many indecencies with wenches, servants and other "working women" at the destinations his role as representative of Virginia led him. Though his wife was well aware of his behavior, for everyone in the colony had heard the rumors, there was nothing that she could do to influence his actions. After her death from smallpox in 1715, Byrd wrote of his devastation at the loss but soon traveled to London, where his reputation reached greater heights. He eventually remarried in 1723 to Maria Taylor. His infidelity, however, endured.

Byrd's desires for women appear to have had little effect on his mind for business. He managed the estate left to him by his father, Colonel William Byrd, and weighed his financial risks carefully. By the end of his life, William II had built a fortune many times greater than a majority of his peers.

Byrd's only son, William Byrd III, was heir to the estate and became the man of the manor at the age of sixteen. Although his father had made attempts to school William III in the ways of business, his bad habits and several poor decisions caused his inherited fortune to disappear nearly as quickly as his father had amassed it.

William III studied law at England's Middle Temple from 1744 to 1748. This time overseas exposed him to many new things in life, including gambling, and gave him a new sensation of independence. Upon returning to Virginia, he made the strategic decision to marry Elizabeth Hill Carter, or Eliza, a member of another of the colony's

most influential founding families. She accepted and joined William on his estate comprising nearly 200,000 acres and hundreds of slaves. It appeared to all that the "Prince of Richmond" had found his princess.

The couple lived lavishly at Westover, surrounded by the finest of everything. They started a family in those plush times and had four boys and one girl to carry on their glory. Sadly, trouble began only a few years after their marriage, and by 1755 they were on the edge of financial ruin. Like the celebrities of today, the Byrds enjoyed a level of popularity that clouded their vision of long-term security and they spent like the supply of money would never run dry. The Byrd plantation was productive and profitable, but William ate away at the profits faster than they could be earned.

In 1756, the Byrds were so deep in debt that William resolved to have the plantation and slaves divided and sold in hopes of keeping his family out of the poorhouse. Though his debt was massive because of his ongoing gambling troubles, the sale of a huge portion of the estate did manage to buy them some time. His gambling losses, however, did not stop with this sobering event.

The strain of money problems, and likely the never-ending gambling problem that was the source of the trouble, led to Byrd shipping his five children off to England in 1756, to be cared for by a distant aunt and uncle. After the children had packed and sailed, he abruptly disowned his wife, Eliza, and volunteered for military service during the war with France. Eliza was confused and troubled by William's actions but tried for four years to repair the relationship. She wrote him regularly during his military service and pledged her love for him, regardless of his past mistakes. In July 1760, she was found dead at Westover, a scene that appeared to be a suicide. Only six months after her death, scandal erupted when William married Mary Willing, the daughter of a merchant and former mayor of Philadelphia. He fathered ten more children.

Financial burden continued to oppress William as a result of his lavish lifestyle and poor self-control. He oversaw the growth and export of large quantities of tobacco and wheat, but he failed to escape his frivolous spending and secret gambling troubles. In 1768, William resorted to one last desperate measure to rise above his debt. The portion of his estate in Richmond, a large number of city "squares," was parceled and

offered as separate prizes in a highly publicized lottery. With tickets at $100 each, Byrd saw the potential for fast, easy earnings with the scheme. Sadly, it was largely a failure. His land in Richmond was sold to eager opportunists, but the earnings were not enough to bring him out of debt.

As William III seemed to have learned bad habits and misgivings from his father, his own children soon showed signs of carrying on these destructive behaviors. Two of his sons were the scourge of the College of William & Mary. They set fires and destroyed school property. It was confirmed just how out of control they had become when Byrd received word that the young men had threatened the life of the school's president.

William's troubles were quickly compounding. Since the lottery, social situations became very awkward, as his friends' and colleagues' suspicions of money problems were confirmed. The ordeal with his sons at college was also a public embarrassment and could very well have been the tipping point in William's struggle.

Just after New Year's celebrations in 1777, William Byrd III retired to a modest bedroom in his ancestral home at Westover. He was found there several days later, dead from a gunshot fired by his own hand.

A Traitor Arrives

William Byrd III gave the town of Richmond a surprising gift with his desperate land lottery—he made parcels of his former estate available to the middle class rather than exclusively to the gentry. The squares won in Byrd's fundraising attempts traded hands and were further reduced and separated into smaller, more affordable plots. In a very short time, a great number of shabby wooden houses lined the streets.

Richmond's population grew at a promising rate, and that growth attracted a diverse, commercial crowd. Merchants brought goods from the Blue Ridge, Williamsburg and even New York and Philadelphia. To help with trade, many of the old, muddy and nearly impassible roads were improved with planks and ditches. Shops, inns and taverns sprung up along the main street as a result. The little town was quickly recognized by the ambitious as an up-and-coming city.

By this time, the capital of Virginia had been moved to Richmond from Williamsburg, where it would be easier to defend. The pride, courage and character of the townspeople were so great that it was noted by many visitors to the young city. These traits proved valuable when Richmond and its people were put to the test in January 1781, during the height of the War of Independence.

Governor Thomas Jefferson received word that Benedict Arnold had landed at Byrd's former home at Westover, accompanied by nearly one thousand British troops, and that he planned to raze the capital. Jefferson

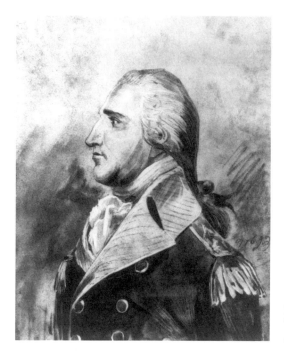

Benedict Arnold, portrait by John Trumbull. *Library of Congress, Prints and Photographs Collection.*

took quick action to move as much city property, tobacco and gunpowder as possible across the James River to Manchester. A call for volunteers was made, and about two hundred recruits were secured—the only able-bodied men available. Half of these raw soldiers were posted near St. John's Church on Indian Hill, and the others were stationed in the Shockoe Valley at the heart of town. Jefferson knew that his small militia was no match in numbers to Arnold's, but every recruit desperately wanted to defend his home.

Arnold marched his men westward, following the James River, and arrived at Rocketts Landing on January 5. From this point, he could clearly see the Americans near St. John's Church. He ordered part of his men to "settle the matter" on the hill. The British soldiers forced the militia to scatter down into the valley, after which they followed, and the entirety of Richmond's little army attempted to push the redcoats back, to no avail. Benedict Arnold led the rest of his troops down Main Street, burning several storehouses along the route to the foundry at Westham. The foundry there was destroyed, and hundreds of pounds of powder were ignited there by the British forces, causing an explosion and fire

seen for miles around. Richmonders thought that the fight was over after seeing the column of smoke rising in the west, but Arnold and his men returned to the city within hours.

The night of January 5 was filled with fire, looting and wanton destruction of private property. Torches were set to many of the town's commercial buildings with little regard for any potential occupants. Arnold made his headquarters at the City Tavern near Main and 15th Streets, and there he feasted to celebrate the havoc unleashed on Richmond by his troops. Meanwhile, those soldiers raided the few remaining storehouses and found hundreds of gallons of whiskey, much of which they drank and the rest they poured into the gutters and streets for the hogs. One witness wrote that it was difficult by the end of the night to distinguish the pigs from the redcoats.

When the sun rose the next morning, Benedict Arnold and his two thousand troops marched back to Westover. With whiskey hangovers and satchels of loot, they did not spare a single look back at the charred and smoking town of Richmond. Though there were no lives lost in the conflict, the British invasion left a deep scar on Richmond's development. The spirits of its people, however, were not damaged; the attack only served to fuel the townspeople's determination and perseverance.

The Fall of the Randolphs

The common people of Richmond felt a strange satisfaction when members of Virginia's First Families were exposed in their adulterous affairs and incriminating plots. None was disappointed when the prestigious Randolph clan became the target of public scrutiny and a legal trial because of their scandalous ways.

Trouble for the Randolphs began when young Richard Randolph married his distant cousin, Judith, in 1789. The two established a plantation at the western edge of Richmond called Bizarre.

Judith's father had recently remarried to a woman only a few years older than herself. Tension in the home had become unbearable for Judith's younger sister, Anne Cary Randolph. Within months of the completion of Bizarre, Anne came to reside there with Judith and Richard.

Anne was a witty and attractive girl of only sixteen. She had several suitors, one of which was Richard Randolph's younger brother, Theodorick. The two, though quite fond of one another, were unable to pursue marriage after Theodorick became terminally ill. He died in Febrary 1792, after more than a year of courting Anne's affections.

On the first of October that same year, Richard, Judith and Anne left Bizarre to visit a cousin, Randolph Harrison, at his estate near Farmville. The events of the evening of their arrival were ordinary until all had retired for the night. Randolph and his wife, Mary, were awakened by screams coming from Anne's bedroom. A servant came to notify them that Anne had taken ill and asked if Mrs. Harrison could take up some medicine for her.

Alarmed by Anne's terrifying wails, Mary rushed a bottle of laudanum to the second floor. When she reached the door to Anne's room, it was locked. Richard was inside and unbolted the door for Mary to enter but told her not to bring in her candle. She spent a short time with Anne, Richard and two slave girls in the dark room. Mary left when Anne seemed to calm down after taking some of the medicine. Later that evening, both Randolph and Mary heard someone come down the stairs and then return within a few minutes.

Judith and Richard acted normally on the following day, but Anne remained in bed to recover from her illness the night before. Mary accompanied a servant upstairs to take the girl a tray of food and saw what looked like bloodstains on the stairs and on Anne's pillow. Inside the bedroom, she and the servant noticed that the bed had no quilt or sheets, though it had both the night before.

The slaves of the Harrison household quickly surmised that Anne had not been ill during the night but rather had given birth. Though none could be sure that the woman had been pregnant, because of the concealing clothing she wore, the strange actions of Richard Randolph and the condition in which the house was left were enough to convince them. One of the slaves shared the conclusion in secret with Randolph Harrison, leading him then to a pile of shingles on the property on which more bloodstains were clearly visible. Some of the slaves even claimed to have seen a white baby on the shingles during the night, but no trace of it remained at dawn.

Hushed rumors spread quickly around the plantation. Harrison did not confront his cousins about the situation, and the guests left on their own accord within a few days. By the time they had returned to Bizarre, talk of an adulterous affair between Richard and Anne, resulting in the murder of an infant, had trickled all the way back to Richmond. When the scandal erupted throughout Virginia's upper class, Richard published an open letter in the *Virginia Gazette* denying the rumors and inviting anyone challenging him to meet him at the next session of the Cumberland Court.

When Richard Randolph arrived at the court session in April 1793, ready to put an end to the rumors, he was met by the sheriff and charged

with "feloniously murdering a child said to be born of Anne Cary Randolph." Richard was jailed and plans for his trial were made.

Randolph hired the young John Marshall and an ill and aged Patrick Henry for his defense. The team had a huge obstacle to overcome in the case—a jury of prominent Virginians who had a history of feuds with the Randolph family. Because the testimony of slaves was prohibited and the Virginia law stated that Richard and Anne could not be required to testify, the only witnesses who could pose a true threat to Richard's freedom were Randolph and Mary Harrison.

During her statement, Mary explained the events of the peculiar night in her home and what she had seen upon entering Anne's room. Both Mary and Randolph testified that they had no suspicions of any criminal activity until after hearing the servants' rumors. No one was able to prove that Anne had been pregnant at all, much less find any proof that a baby had been killed.

The jurors reluctantly agreed with the lack of evidence as argued by John Marshall. The weak testimony of the Harrisons and the only real suspicions in the case being the result of a rumor were not enough to convict Richard or Anne of any crime. Though the pair was cleared of prosecution and punishment by the law, the citizens of Richmond felt that the Randolphs had simply gotten away with murder.

Three years after his trial, Richard Randolph died suddenly from fever. Anne continued to live with Judith for several years at Bizarre but left in 1809 to marry Gouverneur Morris in New York. The younger brother of Richard and Theodorick, John Randolph, became quite bitter toward Anne because of her sullying their family name. The sting he felt when she moved north to join another wealthy, prominent family while his own was the target of constant ridicule drove John to desperation. He drafted a letter to Gouverneur Morris explaining the disgraceful incidents of 1792.

Instead of a reply from Mr. Morris, John and many of his political enemies received one directly from Anne. In her letter, Anne admitted that she had indeed been pregnant and gave birth at the Harrison plantation. The baby, she claimed, had not been killed but was stillborn. Anne denied having an affair with Richard, explaining that the baby had been fathered by Theordorick only days before his death.

While the admissions in Anne Randolph's letter were certainly plausible, they were not accepted by many as truth. Most Virginians had retained the belief that the courts had been correct in their allegations and that she and Richard had fallen to their lowest. It was also speculated that Anne's move to New York was not of her own free will, but rather that the pressures from Richmond society on Judith had prompted her to disown the sister who brought her family so much pain. One can conclude that the true intents and actions of the Randolph family will only ever be known by those involved.

Liquor and Libel

*I*t did not take long for Richmond to get back on its feet after British troops destroyed huge portions of the city. Those who could afford to rebuild their homes and businesses did so; those who could not simply sold their "squares" to someone eager to take a chance on city life. Storehouses and shops were repaired or replaced, and the city continued to attract more merchants and businessmen. By 1790, the town had made a name for itself and was welcoming many newcomers from established cities such as Philadelphia.

One new resident earned the fledgling city quite a bit of attention. He was James Thomson Callender , arguably the most radical writer in the United States during the eighteenth century. After stirring supporters of Scottish independence from Britain with his writing and then facing charges of sedition, the vicious Scotsman's pen effected his immigration to Philadelphia in 1793 to escape prosecution. Callender worked as a journalist in Pennsylvania for a few years and gained a reputation as "the new republic's most notorious scandalmonger."

His written attacks targeted high-ranking political figures including George Washington, John Adams and Thomas Jefferson. History is cloudy in sharing where Callender found the sources and details for his exposés, but his stories revealed many true scandals. One such revelation involved Treasury Secretary Alexander Hamilton. Callender grew suspicious of Hamilton's opinions on foreign policy, finding them too much in favor of

his old enemy, Britain. He struck out with a detailed story that included evidence of an adulterous relationship that Hamilton had with a woman named Maria Reynolds. To pour a bit of salt on the wound, Callender added accusations of Hamilton's financial corruption and his misuse of large amounts of government money. The public's view of Alexander Hamilton was irreparably tarnished. He eventually admitted to having the affair but denied any financial misdoings.

Though Hamilton never served in a public office after this scandal was revealed, he was determined to exact his revenge. In 1798, one year after Callender's venomous accusations were published, Hamilton and his party urged Congress to pass the Sedition Act and make it a punishable crime to write false or malicious statements directed at the president or government body. The act went into effect, and Callender and several other journalists were tried and convicted. Callender was fined $200 and sentenced to nine months in prison at Richmond.

During his time in the Richmond jail, Callender's pen was far from idle. Aware of his keen writing abilities, members of the Virginia House of Delegates sought him out after meetings of the General Assembly to draft pamphlets for distribution to their constituencies. For this service, Callender was collecting in fees for one pamphlet what he would normally earn in a week in Philadelphia. In fact, his business sense was so sharp that he often only changed a few details or names in the draft of one pamphlet and sold it to another representative at full price. Only the printer and delivery boys were on to Callender's game until one delivery was botched and his scheme was exposed. By that time, however, James Thomson Callender was financially secure and set to be released from prison.

His assistance to Virginia legislators was huge. Callender used his work for them as an example of his importance to society when he requested an appointment to the position of Richmond postmaster from the new president, Thomas Jefferson, in 1801. Jefferson refused and ignited Callender's fury once again.

Jefferson was unaware that this journalistic snake was about to strike. All was relatively quiet for a year, but in 1802, Callender released the first of a series of articles claiming that Jefferson had had a decades-long affair with a slave named Sally Hemings and had fathered her five

children. Even though the facts of his work were truth, he knew long before this shocking story hit the presses that the president and those around him would build a huge case against him, using the Sedition Act as a backbone, and prosecute him to the fullest. As this axe was preparing to fall, Callender continued to write—and to drink.

Alcoholism had been a constant struggle for James Callender since his years in Scotland. The troubles he managed to stir with his written work only served to make his drinking problem worse. By 1802, Callender's friend and former defense lawyer George Hay claimed that the writer had grown increasingly bitter since his arrival in Richmond and that his reliance on whiskey had become great. In December of that year, their friendship finally snapped when Hay beat a drunken Callender into a bloody mess for threatening to publish damaging stories about him. By Callender's own doing, the only person on his side who could possibly help him escape Jefferson's punishment was made his enemy.

His drinking became excessive as the weeks passed. On the morning of July 17, several shop owners along Main Street reported seeing Callender hardly able to walk for being so drunk. A few hours later, he traveled down the Shockoe Valley to bathe in the James River, as was permitted for men at the time, and never returned home. Callender was found dead. He had drowned in just under three feet of water.

It is true that he had earned many rivals since his time in the United States, and foul play concerning James Thomson Callender's death was certainly a possibility. Whether an investigation was suppressed by the government or simply disregarded by the people of Richmond, history will never reveal.

The House Is on Fire!

One of the great indulgences of Richmond in the early nineteenth century was attending the playhouse. The city had a new brick theatre, appropriately named the Richmond Theatre, that stood on Broad Street near its descent into the Shockoe Valley. This masonry structure was the pride of the Placide Stock Company players. The new building was a much larger and more respectable replacement for the Beggar's Opera, a wooden playhouse that had burned down on the site a few years before. On December 26, 1811, history would repeat itself.

A fantastic benefit performance for Mr. Placide was scheduled for the night after Christmas, and the event was the topic of conversation in the homes of the affluent as well as those of moderate means. More than six hundred citizens dressed in their finest holiday attire and turned out for the performance. The featured play of the night was *The Father*, followed by the pantomime *The Bleeding Nun*. Between the first and second acts of the pantomime, one careless mistake was later to blame for disaster.

A chandelier used on-stage during the performance was raised into the rafters as planned, but one candle in the fixture had not been fully extinguished. The lit candle set fire to the ropes and rigging, and it quickly spread to the hanging sets and the structure of the stage. The curtain was raised for the second act, and instead of the next scene, attendees were stunned by the words, "The house is on fire!"

Panic and pandemonium filled the theatre. Many were trampled in their frantic attempts to escape the thick smoke and intense heat. Those seated near the top of the house were crushed by the bodies of others when the weight became too much for the stairs and they collapsed. Others resorted to jumping from second- and third-story windows, most either terribly injured by the fall or so burned by the time they managed to make their exit that they met death regardless. Screams and moans filled the street. Every able person near the Shockoe Valley brought buckets of water to try and fight the fire, but their attempts were useless. In what witnesses say seemed like only minutes after the flames were spotted, the Richmond Theatre crumbled into a tangled, flaming heap.

Injured men, women and children were carried to the safety of nearby squares. Bodies of those claimed by the flames or panicked jumps were pulled away from the inferno to be claimed by their families, but many more were lost forever to the smoldering structure.

In the days that followed, a list of the dead was compiled, and the entire nation heard the news of the disaster at Richmond. Killed in the fire were many prominent Richmonders, including the newly appointed Governor George Smith, as well as Abraham Venable, the president of the Bank of Virginia and a former senator. The federal government ordered flags flown at half-mast, and members of Congress wore bands of black crepe on their arms as a show of mourning for a month after the tragedy. State and city government in Richmond shut down for two days, and private businesses locked their doors in this time of grief. Public parties and balls were prohibited for months. The loss, a final count of sixty-eight people, 10 percent of the attendees of the theatre that night, touched the lives of everyone in the city.

Within twenty-four hours of the fire, the city council (then the "common hall") met and appointed Chief Justice John Marshall in charge of the committee formed to raise funds for a tribute to those killed. The city was ordered by the council to purchase the theatre property and use it to inter the ashes of those souls never recovered from the disaster. The first stone was laid on the site for a monumental tomb on August 4, 1812.

Robert Mills of Washington, D.C., was chosen to design the structure. Being the only architectural student of Thomas Jefferson, his plans for the monument complimented the style of the Capitol just a few blocks away

and pleased neighbors, members of city council and those who had lost loved ones in the massive fire. The interior of the building was laid out with two sections of pews, a pulpit, a semicircular balcony and a gorgeous domed ceiling. This "Monumental Church" paid tribute to every life taken that fateful night at the Richmond Theatre with an inscription of the names of each on a memorial at the front portico. The ashes of those who could not be recovered from the blaze were commingled and placed in a huge mahogany box and then into a tomb of brick beneath the church's floors.

The building of a church, as opposed to any other sort of structure commemorating the loss of life at the Richmond Theatre fire, was no accident. The scene of the disaster was described by survivors and witnesses as a "mouth of hell." Richmonders feared that the event had been an act of God, a punishment for all of their sins and wicked ways. Everyone in the city questioned their lifestyle and began looking for ways to make up for past mistakes. Before this turning point, the common people of Richmond were considered raucous and unconstrained, but the religious questions brought to light by this great loss helped to usher the Second Great Awakening into Virginia.

Churches were constructed at a desperate pace, and sermons were preached from nearly every street corner. A huge wave of anti-theatre lectures swept through the East, and Richmond was their origin. Much to the dismay of the city's newly puritan population, the Richmond Theatre was rebuilt at Broad and 7th Streets at about the same time Monumental Church was completed at its previous location. This was deemed an insult. Ministers and preachers tried to persuade their congregations to avoid this den of "vanity and sin." The theatre became synonymous with the devil during this period, and all those who performed in or attended the playhouses were quickly reduced to the lowest levels of society by the newly religious masses.

Remaining true to their wicked reputation, many Richmonders continued to visit the Richmond Theatre among others, despite the warnings from local zealots. The performances there welcomed these rebellious citizens and managed to keep their doors open another fifty years. It was not religious persecution that ended the theatre's run, however. Some called it an act of God and some said it was an accident, but others agreed that it was a curse. The Richmond Theatre was once again reduced to a pile of ashes on January 4, 1862. It was never rebuilt.

The Trial of Aaron Burr

*T*he people of Richmond in the eighteenth and nineteenth centuries had a well-earned reputation of testing political and social boundaries. The gravitational pull of the city seemed to draw a great variety of outcasts, and Aaron Burr, former vice president of the United States, was no exception.

Troubles for Burr began when differing political viewpoints caused a great deal of animosity between him and Treasury Secretary Alexander Hamilton. This tension came to a boil when Hamilton, the very same man so eager to push forth the Sedition Act to prosecute James Thomson Callender, published a series of articles attacking Burr's character. The blow was harsh, especially since it targeted Burr at the height of his campaign for the New York governor's seat in 1804. He was furious.

Laws against dueling were freshly written in many states by that year, but that did not deter Aaron Burr from challenging Alexander Hamilton. The two men, a few friends (or "seconds") and several rowers left Manhattan in small boats and landed at Heights of Weehawken, New Jersey, in the early morning of July 11, 1804. Dueling had not been outlawed in New Jersey, but many people close to Burr were unsure if this was in fact a duel and not premeditated murder. Because of the possible legal ramifications, great measures were taken to protect all witnesses. The rowers stood with their backs to the duelists while each removed his

pistol from a case, allowing those present at the duel to truthfully testify that they saw no weapons.

The site for the event was cleared, positions chosen and weapons readied. Hamilton fired the first shot, but it was high, heading into the trees behind Burr. Burr took the second shot and struck Hamilton just above the hip. The reports of the doctor in attendance explained that the musket ball bounced around inside Hamilton's abdomen, fracturing a rib and tearing several internal organs before lodging itself between two of the lower vertebrae. He collapsed immediately. Burr walked to his opponent in silence, looked down at him for only a moment and was then quickly ushered away by his second to shield him from the view of the rowers. Hamilton died the next day.

After the duel, Burr learned that Hamilton had told friends that he had no intention of killing him, only of firing to prove his courage. This appeared to have little effect on Burr, as he was heard still bragging of the event many years later.

The duel and the death of Alexander Hamilton were at the top of the news in every city and town. When Burr faced charges of murder in both New York and New Jersey, even though both states failed to push the indictments to trial, his celebrity status grew tremendously. Within months of the duel, a traveling showman came through Richmond with a wax representation of the event. It was on display across from Capitol Square at the Washington Tavern, where lines of eager townspeople wrapped around the block, more than willing to trade fifty cents for one look at the spectacle. The Burr-Hamilton duel became firmly fixed in their minds from that day forward.

Aaron Burr spent the next few years moving from state to state. Some said that he was fleeing possible prosecution from his political adversaries, while others claimed that he was working on a plan that could threaten the bonds of their young country. So began the "Burr Conspiracy."

After the death of Hamilton, suspicion surrounded Burr wherever he went—much of it the result of his own questionable actions. Burr raised a large following of sympathizers, some even say thousands, to allegedly move westward with him to territory in Texas leased to him by the Spanish. The conspiracy tells that Burr intended this land to become a new, independent nation, with him as its leader.

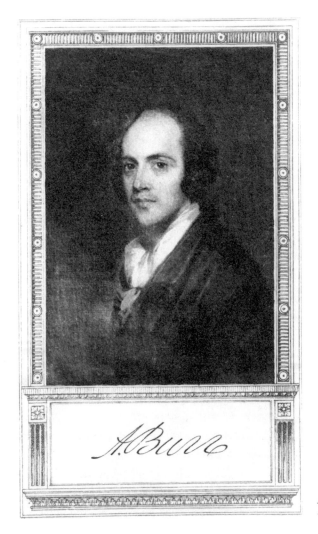

Aaron Burr. *Small, Maynard, & Company.*

A co-conspirator was Burr's friend James Wilkinson, commanding general of the United States Army. Wilkinson's personality was one of ambition and conquest, and his participation in the plan for secession was likely only for the inflation of his already bulging ego. Whatever his motives were, he managed to convince President Thomas Jefferson to appoint him governor of the recently acquired Louisiana Territory. Jefferson, thinking it wise to have a military leader governing such a wild area, had no idea that he had placed Wilkinson in the prime position to further Aaron Burr's treacherous plot.

Wilkinson aided Burr in recruiting sympathizers and even attempted to convince other high-ranking officials of their plan to "farm" a huge portion of the new territory. Burr, however, was growing too bold in his efforts to attract the masses—he instead drew the attention of the U.S. district attorney for Kentucky. Charges were brought against Burr claiming that he intended to ignite war with Mexico, but thanks to his intimate familiarity with the law and help from a savvy young attorney named Henry Clay, Burr was able to have the case dismissed. The district attorney, however, did not fail to inform the president that Burr was a kettle about to boil.

Careful planning on Burr's part allowed the wheels in his conspiracy to keep rolling while he was on trial, but one of those wheels had begun to wear down by 1806. It was either guilt that had caught up with James Wilkinson, or his having convinced himself he would rather be seen as a hero than a revolutionary. He divulged to Jefferson private letters from Burr hinting of the plan of creating a new nation to the west, letters that Wilkinson altered and edited to maintain his own innocence. He told the president that Burr had been spreading his talk of succession in Louisiana, Tennessee and Kentucky and had recently earned the support of the Spanish by sharing his plan to invade and capture Washington, D.C. Jefferson, livid with the news, sent the Virginia militia to capture Aaron Burr and an accomplice, Harman Blennerhassett, on Blennerhassett's island in the Ohio River.

To avoid the Virginia militia sent by Jefferson and the state militia of Ohio—as the governor had by then grown suspicious of the two men and sent his own soldiers to detain them—Burr and Blennerhassett traveled down the Ohio River to the Mississippi. Their goal was to meet up with troops recruited by Wilkinson at New Orleans, not knowing that instead of following through with the plan to meet, Wilkinson had informed the president of their movements. The two were captured in the Mississippi Territory thanks to Jefferson's advanced knowledge of their position, and rumors and fantastic stories of their flight were spread by both the gossiping public and the leading newspapers of the day. Citizens were on the edge of their seats when they got word that Burr had escaped the party that had detained him somewhere near Mississippi.

Aaron Burr was as much a celebrity as George Washington by the time he was recaptured, nearly six months after his daring escape. He was

apprehended in February 1807 in South Carolina and was held at Fort Stoddert. When forces were called on to transport Burr to Washington, D.C., he attempted escape once again but was unsuccessful.

Thomas Jefferson had charges of treason brought against Burr and Blennerhassett for building an army to take New Orleans and force the secession of the western states. Burr adamantly denied the charges, of course, and moved forward with the trial. He was sent to Richmond in March 1807 to make his case in front of Chief Justice John Marshall, a no-nonsense man who would not be swayed by celebrity.

The arrival of Aaron Burr and Harman Blennerhassett in Richmond was an event that drew countless men, women and children to watch for the heavily guarded coach, a spectacle not unlike the bizarre waxwork depicting Burr's infamous duel with Hamilton. Burr's daughter, Theodosia, also came to the city to support her father during the months of his trial. While the men were awaiting trial out on bail, the three were treated like distinguished guests and made friends of Richmond's most prominent citizens wherever they went. One such friend was Mrs. Robert Gamble, the mother-in-law of Burr's prosecuting attorney William Wirt. Her home sat on the hill adjacent to the penitentiary, and she and her friends were known to send fine edibles to Burr and Blennerhassett in prison. A jovial Irishman, Blennerhassett became a favorite of Dr. Brockenbrough, a member of the grand jury, and his wife.

Burr and Blennerhassett were frequent guests at the home of their lead counsel, John Wickham. In some peculiar lapse of judgment, Chief Justice John Marshall attended a dinner at the Wickham house to which the accused had been invited, and he was said to have been kind and convivial toward the two men. Marshall was chastised by the people of Richmond for this action, and the rampant spread of gossip was probably a key factor is his refusing future invitations to dine with the suspects.

The trial for treason climbed to a steady pace. Evidence against Burr and his co-conspirator was lacking, and his defense, knowing their advantage in the court, offered a strategic option—to subpoena President Thomas Jefferson and the documents supposedly in his possession so that they might most accurately represent their case. Jefferson stated that he was not required to honor the request because of his executive privilege but that all relevant papers had been provided for use in the case. John

Marshall did not see matters in the same way and felt that the president was a citizen like any other, regardless of office, and was not above the law. Jefferson refused to participate in the trial, and as a result, the prosecution's case weakened even more.

Marshall, after carefully evaluating the definition of treason, found that not enough evidence was presented to prove that Aaron Burr had committed an act of war. He proclaimed that participating in a conspiracy and *talking* of overthrowing the U.S. government was not considered treasonous behavior. With the echoes of the American Revolution still ringing in the minds of jurors, the words of Marshall were taken to heart. On September 1, 1807, the members of the jury read their verdict for the charge of treason: "We of the jury find that Aaron Burr is not proved to be guilty under the indictment by any evidence submitted to us. We therefore find him not guilty." The cloudy verdict did not please the defense, and Burr's attorneys requested the verdict be clarified to a simple "not guilty," but they refused.

A case was still being argued for a misdemeanor charge filed by the U.S. district attorney of Ohio stating that Burr sent a military expedition to territory belonging to Spain. On October 20, John Marshall laid down his decision. He found that there was enough evidence to send the men to Ohio, where the crime was allegedly committed, so they could be tried.

Aaron Burr and Harman Blennerhassett left Richmond with a grand send-off from the townspeople. The city, which loved a scandal of any magnitude, reeled from the excitement of the celebrity trial for months. Some of the people who had interacted with the men told stories of their encounters for decades. Burr and Blennerhassett were sent westward with farewell wishes of luck and good fortune from the people of Richmond. That luck manifested when the State of Ohio decided not to pursue the charges made against them, allowing the two men to hold on to their freedom.

A Poisoned Statesman

George Wythe, the much respected member of the 1776 Continental Congress and a signer of the Declaration of Independence, moved to Richmond's Shockoe Hill from Williamsburg after the death of his wife in 1791. Here in the state's capital, his legal opinions and advice were greatly valued because of his rounded experience as a lawyer. He gave that advice willingly, even throughout his retirement. From his elegant home overlooking the valley, and at the admirable age of eighty, George Wythe was still able to serve his beloved Virginia.

Wythe is often described as one of the country's most influential statesmen because of his close mentoring of the young and impressionable Henry Clay, James Monroe, John Marshall and Thomas Jefferson. Jefferson, Wythe's most adored protégé, was treated much like the son he and his wife, Elizabeth, had wanted but never had. Jefferson served as a law clerk to his mentor for five years and, during that time, had the opportunity to observe legislative sessions. Wythe introduced his ambitious clerk to several very prominent figures in the shaping of a nation: George Washington, Patrick Henry and George Mason. Eventually, Jefferson came to serve alongside Wythe as a fellow legislator, and the two worked together to rewrite the outdated Code of Laws in Virginia. Wythe's pride in Jefferson and his climb to governor and then president of the United States was like that of a father.

Even in his golden years, Wythe had a place in his heart for helping to educate young men with potential. In his care were a free sixteen-year-old mulatto boy named Michael Brown and the grandson of his sister, also his namesake, George Wythe Sweeney. Brown had shown great promise and was learning law from Wythe, but Sweeney was more a case for repair than one for education. Wythe took him in when the young man's drinking and gambling became a family embarrassment, and he tried to set him on better moral course. In return for his granduncle's charity, Sweeney stole rare and precious law books from his library and attempted to sell them at auction for gambling money. That wicked deed only served to whet his appetite for more, so he soon resorted to stealing and forging bank checks written on Wythe's account. Sweeney had managed to cash six of these forged checks before greed and paranoia prompted him to take his villainous actions to the next level.

Lydia Broadnax, a black woman who had worked as a servant for George Wythe for decades since he freed her from slavery, told her employer that she had seen Sweeney in Wythe's library with his last will and testament in hand. Suspicious of the young man's actions after that incident, Lydia began keeping a close eye on Sweeney's behavior. On the morning of May 25, 1806, while she was preparing breakfast, Sweeney came down to the kitchen and poured himself a cup of coffee. Lydia said that she saw him toss a small piece of paper into the cooking fire afterward but did not think it important until later that day.

Keeping with her routine, Lydia carried a tray of toast, eggs, sweetbread and coffee up to Wythe to eat while he read the day's news. She returned to the kitchen and had a cup of coffee with Michael, who was finishing his meal there. Lydia began the chore of cleaning up the morning's dishes when she was struck with severe stomach pains and became quite ill. She turned to see Michael, who had been clutching his abdomen in pain, collapse across the table. Her thoughts immediately jumped to the elderly Wythe.

Lydia collected herself and struggled upstairs to find her employer weak and vomiting. She helped him into his bed, and he asked that she call for a doctor as quickly as possible. When the doctor arrived to find the three in a terrible state, Wythe managed a whisper that set in motion a sobering chain of events. "I am murdered," he said.

George Wythe and Lydia Broadnax both suspected that Sweeney was at the root of their illness. The best doctors in Richmond—James McClurg, William Foushee and James McCaw—came to the Wythe home to treat the statesman and his two servants, but all believed the household to be suffering from a bout of cholera. Two days after the three fell ill, the doctors were forced to rethink their original diagnosis, as cholera was most often fatal within forty-eight hours of contraction, and Lydia was improving while Michael and "Old Master" were holding fast in critical condition. Meanwhile, on this third day of sickness, George Wythe Sweeney attempted to cash a check from his granduncle's account for $100, a considerable sum at the time. The management at the Bank of Richmond was well aware of Wythe's medical condition and the rumor that Sweeney had stolen and forged checks in the past. A constable was called in, and the teen was held in suspicion of forgery and for possibly harming his caretaker.

Investigators searched Sweeney's room at the Wythe home and found a glass vial of yellow arsenic. The poison was not uncommon to possess, as rats had thrived in the city since the first shanty houses were constructed, and arsenic was the most effective weapon against them. For the young man to have it hidden in his bedroom, however, cast a darker shadow on his character. Lydia Broadnax recounted to the authorities her observations of Sweeney's meddling with the coffeepot the day the others in the house became so sick and her previously having seen him with the Old Master's will in hand. Word of these statements and of the arsenic found in the young man's room spread quickly throughout Richmond. Nearly every citizen had determined that George Wythe Sweeney was a murderous criminal.

On the seventh day after he collapsed at the breakfast table, Michael Brown succumbed to the violent illness that had swept through his home. George Wythe, crushed by the sadness of Michael's death and the fury he felt toward his own grandnephew, called in his lawyer friend Edmund Randolph. Wythe had originally willed part of his estate to Brown and part to Sweeney, but with the recent turn of events, he had Randolph sever Sweeney's greedy ties to his fortune by amending his last will and testament. George Wythe died seven days later.

On June 18, 1806, George Wythe Sweeney was arrested for the murders of his granduncle and Michael Brown. In a strange turn of events, Edmund

Randolph served as the young man's defense, along with an up-and-coming lawyer named William Wirt. The two attorneys built a solid case to defend their client and presented it in court the following September.

Prosecutors called forth the testimony of Sweeney's friend, Taylor Williams, and had him explain how Sweeney had asked where to obtain some poison. Giving his friend the benefit of the doubt and assuming that he intended to use the poison on rats, Williams told him where he could buy the arsenic-based poison called ratsbane. Sweeney seemed pleased at the suggestion, and the matter was not discussed again.

This circumstantial bit of evidence provided by Williams was perhaps the strongest in the prosecution's arsenal. Though Lydia Broadnax had seen Sweeney in the kitchen tampering with the coffeepot the morning of the poisoning, her testimony was inadmissible. Ironically, when Wythe and Jefferson had collaborated to revise the Code of Laws of Virginia, they left alone the law prohibiting any black, free or otherwise, from testifying against a white person in court. In a letter to Wythe during that period of collaboration, Jefferson explains that he did not think that the people of Virginia were as ready as they were personally for the relaxation of laws regarding race. And now, because the case's key witness was unable to tell her story, the defense was able to cast reasonable doubt into the minds of judges Joseph Prentes and John Tyler Sr. That shadow of doubt was growing larger with every piece of evidence presented.

The points of Sweeney asking a friend about poison and the discovery of arsenic powder in his bedroom held very little weight after the defense uncovered the fact that the doctors in attendance to Wythe during his last days and who had examined his body after death all failed to check for the obvious signs of arsenic poisoning. While they found that the statesman's stomach had been irritated and full of bile, not an ailment attributed solely to arsenic, they made no note of the poisoning's biggest red flags: conjunctivitis of the eyes and blackening of the penis. The three doctors could not conclusively declare Wythe's cause of death as arsenic ingestion.

After only an hour of deliberation, George Wythe Sweeney was acquitted on both counts. There was, however, still the matter of a charge of forgery, but justice would fail to be served yet again. A loophole in the law helped Sweeney's cunning defense save him from several years in

prison on the charge. The language in Virginia's code on forgery was just cloudy enough that Randolph and Wirt were able to convince the judges that it pertained to the attempt to acquire money by false means from an individual, not from a commercial bank like in the case in question. Again, doubt and the weakness of the state laws at the time prevented a guilty verdict for Sweeney.

Though he walked out of court a free man, George Wythe Sweeney felt it best to leave Richmond, where he would be permanently criminalized in the minds of its citizens. He was last heard from in Tennessee, where he was arrested for stealing horses.

The biggest scandal to evolve from this shocking series of events was not the treachery of a young man toward his mentor or the failure of the racially biased justice system. The people of Richmond were winded when they discovered exactly what George Wythe had Randolph modify in his last will and testament. Every bit of his estate, with the exception of a few trinkets and the books in his library (which went to Thomas Jefferson), was left to his loyal servant and companion Lydia Broadnax. Citizens drew the obvious conclusion that Wythe and Broadnax had had much more than a working relationship over the years. When the copy of the will written before Michael Brown's death was shared, the public was quick to surmise that Brown was, in fact, the couple's son. Should something happen to him, Wythe had entrusted the boy's care and education to none other than President Thomas Jefferson.

Averted Destruction

Richmond's growth and development after the end of the Revolution did not come without great effort. Setbacks and challenges arose, much like growing pains for the budding town, and social tensions were emerging.

For its time, the demographic of the city in the late eighteenth century was well balanced. Free whites and free blacks were nearly equal in number, but the whites were the minority when black slaves were counted. This tipping of the scale resulted in a quiet undercurrent of paranoia among wealthy whites high on the social ladder. Fear of an uprising was often discussed in hushed tones when servants had retired for the night. None of these fears were solidified, however, until August 1800.

The blacks of Richmond regularly gathered in the Brook Road and Brook Hill areas just north of town. These social sites were venues for religious services (or "preachments"), fish fries, dancing and music. By all external appearances, these outings were happy and harmless. However, a mass-produced letter found on a Yorktown street in 1793 indicated that something sinister was afoot during the weekly gospels—an insurrection organized by a black Richmond preacher. The whites of the city were vigilant, and it appeared that nothing had come of the message spread by the letter. The blacks, who had learned of the French Revolution and the uprising in Haiti, were simply refining their plans over the next several years.

A date for insurrection was set: August 30, 1800. Early that day, a servant of Mr. Mosby Sheppard named Tom was visibly distressed and agitated. When Mr. Sheppard pressed Tom for the source of his nervousness, Tom shared the plan that the local black leaders had formed for the massacre of Richmond's white population. The plan was to begin that very night.

Mr. Sheppard called on Mr. William Mosby of the Brook neighborhood and shared with him the news, including the detail that Mr. Mosby was to be the first slaughtered. The two men went to the mayor and governor and convinced them to raise a volunteer militia to patrol the roads that night near the Brook. As is not unusual in Richmond's summertime heat, a great storm arrived after dark, and its lightning and downpour of rain forced everyone, black and white, inside for the night. The next morning, a servant of Mr. Mosby explained that the plot was not abandoned but would instead be carried out that evening.

By that time, a wave of panic had swept through Richmond. The volunteer guard grew, and with the help of information provided by Tom and another servant named Pharoah, they were able to capture many key operatives in the scheme. Those captured shared the origins of the plot and told of its ringleader, "General" Gabriel, a slave of Mr. Thomas Prosser of Brook Road. Gabriel and his brother Solomon had whispered the plan at the festive Sunday gatherings and found many sympathetic recruits. Solomon, a blacksmith for Mr. Prosser, had converted dozens of scythes and other farm tools into swords. Their plan was for their "soldiers" to use these weapons to seize the arms reserves in the state's capitol and penitentiary with the help of inside men. A great fire would be set near the river at Rocketts, and when the residents poured from their houses to help extinguish the blaze, the rebels would enter the vulnerable and emptied homes. With nearly five thousand men on his side, Gabriel's attack had the strength to shake Virginia to its foundations, but the well-formed plan didn't stop with seizing property.

Gabriel, with his great army, had hoped to gain the sympathy of enough blacks to fill Capitol Square and force all of the city's white population into the river. One young recruit was even noted to have told Gabriel, "Here are our hands and our hearts. We will wade to our knees in blood sooner than fail in the attempt."

General Gabriel, not wanting to be seen as a crazed killer free from conscience, ordered Methodists, Quakers and poor old women without slaves to be spared from his destruction. He had also hoped to gain the aid of the French in the area and suggested that no harm come to them until they could make their decisions. Gabriel ordered that Mrs. David Meade Randolph, who ran an inn on Cary Street, be spared above all others. He planned to make her his queen because of her vast knowledge of housekeeping and cooking.

When the whites of Richmond were dead, those who fought in Gabriel's army were to have first pick of their homes. Their leader's ambition was not limited, however, only to Richmond. He planned to fortify the city and then continue his slaughter and conquest throughout Virginia and then across its borders. But thanks to Tom and other informants like him, the plan was choked out before the first life could ever be taken. Gabriel, Solomon and their "captains" were captured, tried and hanged.

The people of the town never truly rested after details of the failed massacre were released. Constant fear resulted in the establishment of night watches in each ward. The watchman's calls of "Oyez, Oyez, one o'clock and all's well" may have helped them sleep, but the possibility of a future rebellion lingered in the back of their minds for decades.

Pirates at the Penitentiary

Richmond's attraction of the wicked proved powerful once again. The careful judgment of Chief Justice John Marshall was called upon in 1827 to oversee another highly publicized case when three Spanish pirates were captured near Hampton and brought to the Henrico jail on Main Street to await their trial for murders committed aboard the brig *Crawford*.

The men—José Cesares (also called Pepe), José Morando and Felix Barbeito—were the only three tried, but the most despicable member of these seafaring butchers was Alexander Tardy. Witness testimony related how Tardy had been pulling the strings during the takeover of the ship and even more so during the execution of the passengers and crew. Marshall would hear the arguments and decide whether Tardy alone should receive the blame for the murders, or if the three men brought before him had acted on their own impulses and should be found guilty of the crime.

The brig *Crawford* departed Providence, Rhode Island, bound for Cuba to retrieve a shipment of sugar, molasses, coffee and rum for New York City. They sailed on April 6, 1827, and arrived at the Caribbean in mid-May. The ship reached port, and the crew began loading the cargo, a process that took several days. While in port, Captain Henry Brightman informed his men that they would be taking on four foreign passengers for the return trip, news that none protested. Making a little more money on the side by ferrying travelers would be easy work and welcome income.

The ship received its papers and set off on its return voyage on May 28. Three days after returning to sea, Alexander Tardy, an alleged doctor, insisted on helping to serve a breakfast of eggs, ham and bowls of chocolate. He passed around second helpings of his special Spanish cocoa and praised the mate, Edmund Dobson, for finishing it. After breakfast, Dobson retired to the stateroom to rest, as he had been awake all night on duty. During his witness testimony, he professed to soon feeling "giddy in the head and quite sick on the stomach." The captain came down to assess Dobson's condition and then invited Tardy to see him and give his medical opinion. Tardy declared Dobson cathartic and prescribed a medicine to remedy him, but Dobson refused it at the urging of the ship's cargo chief, who had seen the "doctor" and his men acting suspiciously.

A short while later, Dobson came up on deck and rested on a mattress, where he stayed all day with illness. The cargo chief, Robinson, told the crew in confidence that he had no doubt that Tardy and his men had given them *all* poison and that no one should eat of anything the Spaniards had a hand in. All were keeping a close eye on their dubious passengers, but none suspected that they might have been capable of the violence and treachery that unfolded later that night.

Dobson, still on deck, awakened when a seaman came up at midnight to relieve the man at the helm. He informed the replacement to alert him to any change in the weather and then returned to sleep. The sky was clear and stars danced above the waves, but there was no moon that night to reveal the men ascending to the deck in darkness. Dobson woke to a confusing noise and rose to investigate it. When he neared the windlass, he saw the shape of a man standing with a knife in his hand. Dobson had no time to react, and the figure stabbed him in the shoulder.

Dobson's shouts and the clamor that began on deck raised the rest of the crew from below to investigate. Even with the wound to his shoulder, he was able to reach the longboat and retrieve a handspike for his own defense. He caught sight of Dolliver, the seaman at the helm, and Potter, another sailor who must have ascended after hearing the commotion, both gripping whatever they could reach to keep from collapsing. Dobson testified that the injuries to both men were severe and that their blood "streamed like rain" over himself and the rigging. Dolliver told Dobson

that Tardy had come to the helm and looked around and then, out of nowhere, had cut him in the neck.

Calls for help came from the water near the ship, and Dobson recognized the voices as those of crewmembers Robinson and Nathan. Both pleaded to be helped aboard, but the Spaniards refused to let anyone go to their aid. When their cries continued, the Spaniards even attempted to stab Nathan with a harpoon.

Dobson heard the sounds of bodies being tossed overboard and then heard the passengers talking about him, inquiring whether he was alive or dead. Tardy called to Dobson and asked if he was wounded, adding that he should come below deck, where they could talk with him. Dobson answered that he wouldn't go below to be slaughtered but preferred to die with his shipmates. Tardy assured him that he would not be killed and that he was an asset they needed to complete their bloody voyage.

Tardy ordered the Spaniards to bring up his medicine chest from below so he could treat the wounds of the men they needed to help sail the ship. They refused, saying, "There is enough time for that later." Tardy then announced to everyone on the ship that they should come down from their hiding places and join him and the other passengers on the deck. After much hesitation, Dolliver was the first to oblige. Tardy was standing at the helm, and as Dolliver came out into the open, he was encircled by the Spaniards. Dobson then saw José Morando lurch forward and stab Dolliver in the abdomen. Pepe waited for José to withdraw his blade and rushed forward to strike Dolliver with enough force to knock him overboard.

Dobson and two others were drawn out to find the Spaniards shirtless and covered with blood. Dawn was breaking when Dobson and his men were ordered to clean the blood and carnage from the deck and the sails. The scene was so gruesome that some of the sails had to be painted over after their attempts to clean them failed. By this time, all four villains were deep into bottles of spirits in celebration of their victory.

The ship's flag was replaced with a Spanish one in an attempt to disguise its origin. The three butchers and their ringleader, Tardy, destroyed the ship's papers and even threw pages of the crew's Bibles overboard to eliminate any evidence of the brig's identity. One of the men produced a counterfeit set of papers obtained in Havana that represented the ship

as bound for Hamburg, Germany—to where Tardy then ordered the crew to prepare to sail. His plan was to stop and load supplies for the transatlantic voyage somewhere along the coast. The suggestions of Savannah and Charleston were made, but Tardy had operated a failed and unscrupulous business in those areas and feared recognition. Instead, he decided to make port in Chesapeake, and Dobson was ordered to navigate the course.

The only crew left alive for the voyage were Dobson and a young black cook named Stephen Gibbs. Another paying passenger, a Frenchman named Ferdinand Ginoulhiac, had managed to avoid the murderous rampage of the Spaniards and made himself as useful as possible in sailing the ship so that he might make it to land alive. Tardy steered the vessel occasionally, but the three Spaniards did nothing to assist. Piloting the ship with only a fraction of the men normally needed to do so, Dobson and his two companions eventually brought it to rest within sight of Old Point Comfort near Hampton.

Edmund Dobson readied a rowboat for Tardy to take ashore. Only moments before the head of the gang of devils descended into the tiny craft, Dobson made a risky maneuver. Knowing that there were no munitions on the ship with which the Spaniards could stop him, he grabbed the oars and rowed as quickly as his tired arms and injured shoulder could manage. He left Alexander Tardy red-faced and shouting from the *Crawford*'s deck.

Dobson made a hasty escape to the construction site of Fort Monroe at Old Point Comfort. He was helped ashore and taken to Captain Nathaniel Dana, who listened to Dobson's horrific account of the voyage from Cuba. Captain Dana ordered a party of nine men to board the brig *Crawford* and to bring everyone they found there in for questioning.

Dana's men captured the three Spaniards in nearby Isle of Wight after they had tried to flee in a small boat they stole from a nearby ship. Tardy was found dead in the stateroom of the *Crawford*. According to Gibbs the cook, Tardy was so distressed by the thought of capture that he cut his own throat soon after Dobson escaped on the rowboat. While the Spaniards were sent to Richmond to face trial before Chief Justice Marshall, Tardy's head was removed and sent to Baltimore for medical study.

The survivors of the bloody ordeal were obviously traumatized and frightened, but both Dobson and Ginoulhiac relayed from the court's witness seat the details of their bizarre time aboard the brig *Crawford*. Huge crowds turned out at Richmond's Federal Circuit Court to hear for themselves what had been a leading story in newspapers around the globe. True to their reputations, the Richmonders in attendance were loud and disorderly spectators, and Chief Justice John Marshall had to work diligently to keep his famously even temper in check. Thankfully for him, the trial that began on Monday concluded only two days later. Deciding the fate of those charged moved even more swiftly, as once all of the witnesses and arguments were heard, the jury deliberated only a few minutes. The verdict was announced: José Cesares, José Morando and Felix Barbeito were all found guilty of piracy and murder. They were sentenced to be hanged at the state penitentiary on August 17, 1827.

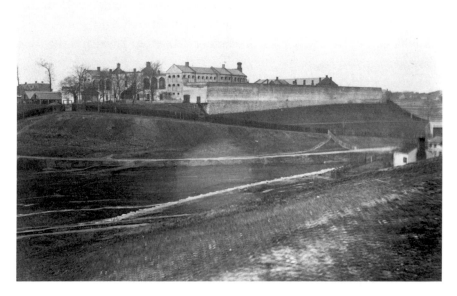

Virginia State Penitentiary during the nineteenth century. *Library of Congress, Prints and Photographs Collection.*

Public execution was the custom of the time, and nearly ten thousand men, women and children turned out to line the wagon's procession from the county jail to the state penitentiary and to see the killers drop from the gallows. They were hoping for a newsworthy spectacle and were certainly not disappointed.

The pirates were met at the gallows by a Protestant minister, who preached a short sermon using the three men as examples of what happens to those who lead lives of sin. A Catholic priest followed and administered the last rites while the men had their hoods and nooses readied. Cesares, Morando and Barbeito were side by side when the trapdoors below their feet fell open. In a strange turn of events, the ropes belonging to Morando and Cesares snapped, and the men tumbled to the ground amid the gasps and screams of spectators. Barbeito writhed at the end of his rope, while his companions, probably thinking they had escaped death that day, were fitted with new ropes and dropped a second time.

Many who had come to see the execution had been so distraught with the failed first attempt to hang the men that they fled before the pirates met their end. Those who remained filed by to see the three bodies twitch and sway on the gallows for more than an hour before the bodies were removed and buried in a plot near the penitentiary.

When the crowds had cleared, the three bodies were exhumed and sent to the Armory at 6th Street and used in medical experiments. Mary Shelley's *Frankenstein* had been published only a few years earlier, and curious doctors took the opportunity to use the remains of the pirates in "galvanic testing"—a process in which electric current was applied to the bodies in an attempt to revive them. Of course, these attempts failed, and the three pirates were returned to their shared grave. The remains of the men are now rumored to lie somewhere under a street in Oregon Hill, entombed by the progress and development of the city.

The Enquirer v. the Whig

During the early days of the nineteenth century, Richmond saw more than its share of newspapers come and go. The news styling of the period was extremely skewed politically, with most papers clearly announcing their party of choice, and editions consisted mostly of rants and complaints toward the opposition rather than current events. The *Enquirer* and the *Richmond Whig* were no exceptions.

Thomas Ritchie was an ambitious young publisher from Tappahanock and the relative of several prominent Virginia politicians. He was a devout Democrat and was extremely vocal on all matters concerning states' rights. At the urging of Thomas Jefferson, Ritchie settled down in Richmond and began distribution of the *Enquirer* in 1804. The publication was intended to act as a Democratic journal, educating the people about the party's message and gaining the support of voters in this now thriving metropolis. Twenty years of success and prosperity passed for Ritchie— and then competition arrived.

John Hampden Pleasants of Goochland, son of former Virginia governor James Pleasants Jr., found himself acting as the literary mouthpiece for the strong central government counterparty, the Whigs. He founded the *Richmond Whig* in 1824 and quickly gained a loyal readership. Pleasants had a thorough knowledge of law having studied under William Wirt and operating his own practice in Lynchburg for several years. This, combined with his keen attention toward "middle

class" issues, helped to propel the success of his paper within Richmond's working population. Whig Party supporters rose greatly during that decade, and by its end the political views of the city's residents were near evenly split.

During the 1830s, talk of banning slavery became a hotly contested issue between the Democrats and the Whigs. The topic had clearly gotten under the skin of all citizens, North and South, and featured prominently in debates concerning the possible annexation of Texas. Both parties also shared concerns that the British might form an alliance with the Texas territory and place their young nation in a sticky geographical situation with a potential enemy on its western border. Though the colonies had gained their independence from Britain sixty years before, the lines of communication and trade were still being reformed. Trust of this former parent nation had not yet developed.

The rival editors lashed out at their opposing parties, as well as each other, in often venomous articles and essays distributed in and around Richmond. Their loathing grew so intense that even Ritchie's sons, William and Thomas Jr., became quite vocal in the media and on the streets about their father's enemy. Situations escalated, and one particularly nasty remark from Pleasants earned him a challenge of a duel from William Ritchie. Rumors flew and the public rippled with excitement, but William, either at the urging of his father or the reasoning of his conscience, withdrew the challenge before it could ever be acted upon.

Threats from Ritchie's children, who were soon stepping up to take over the *Enquirer* so that their father might retire, did not even slow down the presses at the *Richmond Whig*. John Pleasants and his staunch support of anti-Democratic policies, especially his support of slavery, drove the Ritchie family mad. The personal attacks in the papers increased, and a few Richmonders of the time even noted bearing witness to violent shouting matches between the men when they had the unfortunate luck of passing in the streets.

Ritchie eventually handed down the ownership and control of the *Enquirer* to his sons, but rather than retire, he moved to Washington and assumed the role as editor of the *Washington Union*. Pleasants, no doubt feeling that he was now the superior pen in Richmond, continued to rally

the public to agree with his views of Congressional supremacy, economic protectionism and his support of slavery. The latter soon reached a boiling point within the Whig party, dividing it to the point of near collapse, and gave the Democrats a target at which to aim.

Thomas Ritchie Jr. saw this new weak spot and took the opportunity to fling some piercing remarks at John Pleasants, specifically one calling him an abolitionist coward. While political argument kept him motivated to debate with his temper in check, this accusation of cowardice tipped the scales for Pleasants. He responded by offering to settle the matter with a duel.

Pleasants told Ritchie to meet him in Manchester on the morning of February 25, 1846, with his pistols. It was tradition, and commonly accepted as some kind of "dueling code," that the challenger would allow his opposition to choose the time, place and weapons to be used. Ritchie protested that the duel was "not consistent with public honor" but made it clear that he would be present at the time and place Pleasants had instructed.

The day of the challenge arrived, and Thomas Ritchie Jr. came to Manchester at dawn with four dueling pistols in his belt, a sword under his coat and a six-shooter in his pocket. Accompanying him, as was customary, were two friends. William Scott served as Ritchie's second. The events that followed are still fuzzy, and even the witnesses who observed the duel are unclear about what exactly took place. According to Scott, Ritchie and Pleasants greeted each other, took their places and then drew weapons. Pleasants fired but struck no one. Speculation was that he had loaded his own gun with blanks and merely intended to frighten his rival instead of killing him, like some sort of strange practical joke. The matter was no joke to Ritchie, however. He took aim and pulled the trigger on one of his dueling pistols. Pleasants fell dead at the scene.

Thomas Ritchie was tried for the death of John Pleasants but was acquitted because no laws were on the books prohibiting dueling. While the two men had chosen every word in their ongoing published battle very carefully, their actions were brash. The personal attacks between Ritchie and Pleasants were over, but the politically opposing newspapers continued the literary feud until the papers themselves dissolved many decades later.

Hell on Earth

By 1830, the Kanawha Canal and ever-expanding railroad access allowed the low, nearly useless area known as Shockoe Bottom to grow and prosper as a center of trade in Virginia. Sadly, after the ban on imports of African slaves to the United States in 1807, a major product of trade in the state was humans. African American slaves were bred on tobacco and cotton farms in Virginia, sold to brokers (a middleman of the transaction) and then auctioned off to plantation owners in the Deep South, who were much more reliant on this source of labor.

Richmond's central location and convenience to rail and water transportation made it the hub of the Virginia slave market. Brokers and auctioneers flocked to the city and built businesses that thrived until the start of the Civil War. One such broker, the most notorious of the lot in Richmond, was Robert Lumpkin. Lumpkin was described as a "shady" businessman, as one would expect from a man who dealt in human slavery. He had failed at several different ventures before moving to the city and building his infamous "Negro jail."

Lumpkin purchased a parcel of land near 15th and Franklin Streets where a trading compound was erected on the sloping terrain. He placed his residence at the highest point, and at the lowest he built a two-story brick structure to house his living inventory.

Conditions for the men, women and children held at Lumpkin's Jail were deplorable. One writer of the period described the building as more

suitable for livestock than people. There was a room established purely for torture, appropriately named the "whipping room." Holding cells were more like stalls in a stable than anything else. The reputation of the jail earned it the nickname "the Devil's Half-Acre," and a mere mention of it could send slaves into a panic.

Robert Lumpkin seemed to be a man who enjoyed spreading fear and misery. He would often observe beatings at the whipping room and then return home for a pleasant meal, the wails of the punished still carrying uphill and into his windows. Lumpkin's cold demeanor apparently helped him to succeed in his wicked business. Between 1840 and 1862, more than thirty thousand slaves were sold at his auction block.

When the war came to Virginia, Lumpkin found it best to send his two young daughters north for an education. Ironically, the girls, who appeared white, were actually of mixed race. Their mother, Mary, was a

The Shockoe Bottom area after Reconstruction. *Detroit Publishing Company.*

freed slave who had lived with Lumpkin since his arrival in Richmond. While he attempted to protect the girls, his heart was still festering. He admitted a fear to a friend: if his daughters stayed in Richmond, he may be forced to consider selling them into slavery if the economic tide of war threatened his livelihood.

The war did slow the slave trade in Virginia, as it did all other forms of commerce. Lumpkin soon found the numbers of prisoners in his inventory dwindling. With Libby Prison, Belle Island and even the Henrico County Jail filled with Union soldiers, he eventually offered space in his facility to aid the Confederate cause—for a fee, of course.

Lumpkin's Jail and another in the slave exchange district, Castle Godwin, were soon filled to capacity with Union sympathizers. Those to be punished most severely were reserved for Lumpkin's wretched compound. When members of the Union army marched into Richmond in April 1865, they found those confined there nearly starved to death and on the brink of madness. Robert Lumpkin fled Richmond before the city fell and joined Mary and their daughters in Pennsylvania.

Lumpkin became ill and died not long after the war ended in 1865. In an odd twist of fortune, he left all of his property, including that in Richmond, to Mary. Though she had assumed the role of his wife over twenty years earlier, Lumpkin listed her in his will as simply "a woman with whom I reside."

Mary returned to Richmond in 1867 and met a Baptist minister from Boston named Nathaniel Colver. He was in search of a building in which he could establish a school for former slaves. Mary offered him the facility that was once Lumpkin's Jail, thinking it only fitting that a new page in history be written for the despicable place.

Reverend Colver founded the school later that same year, and it grew and flourished. Colver's school remains today, though it has moved to larger grounds within the city and is now known as Virginia Union University.

Espionage

One brave patriot may forever live in infamy in Richmond history because of her wartime treachery toward the city she called home. Elizabeth Van Lew, or "Miss Lizzie," grew up on the peak of Church Hill, just across the street from the site of Patrick Henry's moving "Liberty or Death" speech. One would be hard-pressed to find a homestead more fitting of a true Southern lady, but Miss Lizzie was regarded instead as an eccentric spinster.

After the death of her father, John Van Lew, when she was only twenty-five, Elizabeth resided in the family's stately mansion with her mother. While her brother had taken over their father's hardware business, she had certainly taken over management of the household. One of the first things Elizabeth did with her management role, much to her mother's disappointment, was to grant the Van Lew slaves their freedom. When she heard of children or close relatives of those slaves being sold, she bought every one at auction and set them free as well. Because of her kind heart and outspoken attitude toward human enslavement, nearly all of the servants stayed on as paid employees of Miss Lizzie and were unquestionably loyal to her.

Perhaps it was her sharp, birdlike features or her unorthodox behavior toward blacks that set much of the townspeople against her, or maybe it was her opinions regarding political matters that really got under their skin. Elizabeth was well educated and preferred not to take the polite, submissive

role that the majority of women had accepted at the time. She earned a reputation as an old maid (though she was barely forty) with a venomous tongue. There was no argument from which she would willingly back down.

When the buzz of secession came to Richmond, Elizabeth tried her hardest to repress the idea and spoke openly about forming stronger bonds with the Federal government. She was smart enough to quiet her opinions after the new Confederate flag was raised over the capitol building in the center of the city. It was no secret that Union sympathizers were publicly humiliated and jailed for "turning their backs on Virginia."

Though she had reined in her public comments, Elizabeth's loyalty to the Union and her passion for the freedom of all people were as strong

Libby Prison in 1865. *Library of Congress, Prints and Photographs Collection.*

as ever. After the First Battle of Manassas, a great number of Northern prisoners were brought to the converted warehouse near the canal called Libby Prison, practically in Elizabeth's backyard. When she requested permission to visit the Union soldiers held there, she was swiftly denied. Miss Lizzie soon learned that flattery was her most effective method of persuasion, and she used that skill to gain the trust of officials. As a result, she received a pass to go in and out of the gates of Libby Prison as she wished.

Elizabeth worked diligently to form secret allegiances throughout the Confederate hierarchy in Richmond. One such ally was Lieutenant Todd, Mary Todd Lincoln's half-brother and the commanding officer at Libby. With his help, her plot of exchanging military secrets with Union prisoners held in his ward was carried out for well over a year without suspicion. When guards began questioning the woman's agenda or even searching the food and books she brought to the inmates, Elizabeth was cunning enough to uphold the image of innocence.

A guard once accused her of smuggling secret messages in the false bottom of a dish, which she had done on previous occasions without being caught, and demanded to search the food she carried in that afternoon. Miss Lizzie passed the man the dish, which she had been holding in her shawl. He screamed out in pain and cried for her to take it back. The "false bottom" had been filled with boiling water, for which it was designed. As this incident demonstrated, Elizabeth was quite sharp—very different from the "Crazy Bet" personality she had learned to portray.

The Van Lew servants were critical to Elizabeth's operations with the Union. She had four or five servants ready at any given time to run "errands" as the need arose. The family still maintained a small vegetable farm outside the city, which gave her employees a plausible reason to come and go through Richmond's defensive line. There was never any trouble with Confederate guards searching the produce baskets or parcels of eggs, which would sometimes contain a hollowed shell with a ciphered message hidden inside. This simple farm errand served her plan well for the duration of the war. Elizabeth's employees could, depending on the Union army's position, even ride from Richmond directly into Yankee camps to exchange messages with officers in person.

Miss Lizzie's espionage was not always smooth and easy. She was constantly followed by detectives, as were many of her neighbors, causing tension and hostility in much of the Church Hill neighborhood. Even with the prying eyes of those around her and the perpetual police shadow, Elizabeth kept her true mission secret.

"Crazy Bet" did not do much to try and redeem her reputation with fellow Richmonders. She was criticized for pouring her family's fortune into supplying provisions to Union prisoners instead of sending food and clothing to the Confederate men trying to defend the city from invasion. Elizabeth began wearing a vacant smile, listing to one side and dressing in her most ragged garments to make those who criticized her assume she had simply lost her mind. The tactic worked, and few attempted to approach her when they saw her on the streets.

Many of Elizabeth's actions contributed to her "Crazy Bet" persona, though not all of them were intended to do so. One of her journals tells a story of the Confederate army seizing all civilian horses and mules for use in the war effort. Upon hearing the news that officials were coming for the horse her messengers relied on to relay important communication, Elizabeth hid the animal in her smokehouse. When she got word that the officials planned to return the next day to search for the horse, likely due to a tip from a resentful neighbor, she and her servants moved the horse into the mansion after dark. There she had prepared the second-floor library by spreading straw on the floors and hanging quilts on the walls and over the windows to muffle the sound. She later praised the horse in her journal and remarked how he had been quite cooperative about the ordeal, withholding any stomps or neighs until the Confederate investigators had left the grounds.

As the war dragged on, Elizabeth grew bolder with the moves she made to help the Federals. In February 1864, she was told that "there was to be an exit" at Libby Prison, a grand escape that she would aid by providing hiding places in her mansion and assistance to those men in making the journey back into Union territory. A niece recalled sneaking a glimpse of one such hiding place in the Van Lew mansion when she secretly followed her aunt upstairs to a back bedroom. There, she saw Elizabeth touch a panel in the wainscoting and slide it aside, revealing a tiny secret room. Inside, there was a thin, bearded man who gratefully

The Van Lew Mansion on Church Hill, circa 1900. *Detroit Publishing Company.*

accepted a plate of food from her. She slid the panel back in place and casually went back to her evening.

Eventually, Miss Lizzie became restless with providing small-scale information to Union officers and sought a way to find out pivotal Confederate plans. Using the Van Lew family's influence, Elizabeth convinced Confederate president Jefferson Davis to employ one of her former servants at his White House. The arrangement proved crucial during the final months of the war, and the servant girl, Mary Elizabeth, was even able to share with Miss Lizzie the best time for the Union army to press toward Richmond's defenses, pressure that eventually led to its downfall.

On April 3, 1865, Elizabeth Van Lew received word that Mayor Mayo had met with Union general Godfrey Weitzel at Tree Hill Farm, just east of Rocketts, and had surrendered Richmond to the Federals. When the news hit the rest of the city, panic erupted and civilians gathered all they could carry and fled to the west. Elizabeth, however, unfurled an

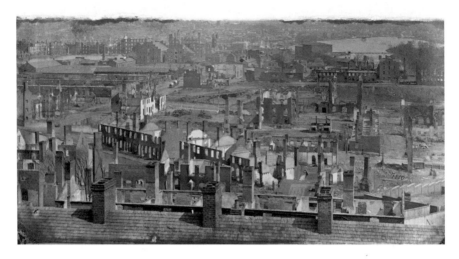

A view of Richmond after the evacuation fire of 1865. Photo by Alexander Gardner. *Library of Congress, Prints and Photographs Collection.*

American flag and hung it across the top of her Church Hill mansion. Hers was the first to be displayed in Richmond since Virginia's secession.

Elizabeth's neighbors were furious at the sight. Knowing that their suspicions had been true all along, many gathered around the Van Lew house and eventually attracted others to form an angry mob. Instead of backing down at the sight of the torch and hatchet-wielding crowd in her yard, she marched out the front door and pointed her finger at several of those present. "I know you, and you. General Grant will be in town in an hour. You do one thing to my home and all of yours will be burned before noon!" Whether it was fear of the Union army's retaliation or fear of "Crazy Bet" herself, the mob quickly scattered and no harm came to Elizabeth or the mansion.

The fleeing townspeople set fire to storehouses and blew up powder magazines and other weapons reserves to keep them out of the hands of the Union troops marching on the city. The fires spread rapidly, but Miss Lizzie remained true to her cause despite the disaster that surrounded her. She was found sifting through the smoldering rubble of the Confederate capitol by a Union officer sent to act as her guard, searching desperately

for any documents that may aid General Grant and his army. Grant was so moved by this act, and of course by Elizabeth's service during the earlier years of the war, that he and his wife paid a special visit to the Van Lew mansion after the surrender at Appomattox to take tea with her and the servants who had worked by her side.

During the years of Reconstruction, the people of Richmond still regarded Miss Lizzie as a traitor to her city. Perhaps it was her years of spying that fueled their bitterness, or maybe it was the jealousy they felt when watching her life come back together more quickly than their own. Elizabeth remained steadfast and as stubborn as ever, refusing to leave the home she grew up in, no matter how many hateful things were said or written to her. She had the last laugh when her espionage was rewarded by the Federal government with her appointment to the position as postmistress of Richmond.

Her death in 1900 was announced with only a short obituary in the local newspapers but with grand, full-page retrospectives in the digests of Philadelphia, New York and Boston. Her grave at Shockoe Cemetery was marked with a simple headstone provided not by family in Richmond but instead by her friends in the North.

Lewis Ginter and his Hotel

One Richmond landmark that has attracted the rich, powerful and, of course, the scandalous is the Jefferson Hotel. This famous building was a product of the "Father of Elegant Richmond," Lewis Ginter, a man whose life was filled with more disasters than his gorgeous hotel.

Ginter was born in New York City in 1824 but made Richmond his home in 1842. He was a motivated businessman in his youth and operated a shop selling imported linens on East Main Street. Focusing on quality goods and fair prices, Ginter earned a solid reputation that helped propel his company to financial success.

The economic crisis of 1857 placed Lewis Ginter in a position as a business owner that taught him lessons about planning and risk-taking. Those lessons served him well when war came to Virginia in 1861. Ginter was forced financially to close his linen business, which was in debt of more than $250,000 at wartime thanks to outstanding debts, and he then volunteered with the Confederate army.

The Civil War, as long and difficult a struggle as it was for Virginia, gave Lewis Ginter the opportunity to test his courage and make many new friends. During Reconstruction, these new contacts and an enduring friendship with his former clerk were essential in his securing a job in his native New York. He soon became the head of a Wall Street banking house.

Good times never seemed to last long for Ginter. In 1873, he found himself unemployed and penniless for a second time after another financial panic that year resulted in the ruin of his business. Despite the turmoil in his life, Ginter was already planning his next venture, as well as his return to Richmond. After nearly a year out of work, he partnered with John F. Allen to form what would soon become a tobacco giant: John F. Allen & Company.

Richmond was rebuilding from wartime destruction rapidly in 1874, and the tobacco trade was one of the first industries to get back on its feet. When Allen's manufacturing experience and financial support merged with Ginter's knowledge of tobacco and his keen eye for spotting emerging trends, their business grew as quickly as the city around them. Ginter had traveled extensively during his time in the linen trade and had noticed the rise in popularity of cigarettes over plug smoking in Europe and New York. Determined to be a leader in this new market, John F. Allen & Company presented Virginia-grown tobacco in cigarette form at the 1876 Centennial Exposition in Philadelphia. The public was far more receptive than either partner had imagined, and a huge boom in business was the result. After five years of prosperity, John Allen sold his portion of the partnership to Lewis Ginter, who then sold a smaller interest in the company to John Pope. With Ginter at the helm, sales continued to thrive, and by 1888 the company was incorporated.

Again, Ginter's good fortune would be tested. The fire of 1893 destroyed the factory at 7th and Cary Streets and all of its equipment. Ginter promised the two hundred employees who suddenly found themselves jobless that he would have them back to work before the end of a month. Telegraphs were sent to order new machinery, much of which was paid for out of Ginter's personal assets, and the manufacturing operation was moved to one of the company's warehouses at 25th and Cary Streets. Ginter kept his promise and had his workers back at their posts within two weeks of the fire.

The wealth that Lewis Ginter built as a result of his thriving cigarette company was never considered by him a golden egg to be tucked away for safekeeping. Ginter was quite the philanthropist, giving money to children in need, helping new businesses to get off the ground and aiding in the construction of several buildings to benefit the Richmond community.

John F. Allen & Company, renamed Allen & Ginter, rose above the competition thanks to Lewis Ginter's idea of collectible cards like these "Fans of the Period" included with each package of cigarettes. *Schumacher & Ettlinger.*

His largest project, and ultimately his final, was his establishment of the Jefferson Hotel.

The hotel was not only awe-inspiring because of its size and fine craftsmanship, but also because of the budget that accompanied a project of that scale. Upon its completion in 1895, Lewis Ginter had spent more than $2 million to see his vision of the hotel become a reality. All of his

hard work and financial outlay had been met with enormous gratitude by Richmonders, and the hotel became the pride of the city. The building's marble floors, mahogany paneling and ornate stained-glass windows and skylights were more luxurious than many people in Richmond had ever seen. Their exposure to these fine details and the hotel's many impressive architectural elements helped to usher in a renaissance of sorts in construction in the city. During this time, many more elegant structures were built in the hotel's neighborhood of Monroe Ward, as well as along Monument Avenue, most of which drew their inspiration from the Jefferson.

The Jefferson Hotel as seen from Franklin Street, circa 1910. Photo by William Henry Jackson. *Detroit Publishing Company.*

The hotel was one of Lewis Ginter's proudest accomplishments, but his joy was short-lived. He died less than two years after opening the doors of the establishment to guests. The people of Richmond mourned the loss of the millionaire, who had encouraged them so much during Reconstruction, like the loss of a brother. The *Richmond Times-Dispatch* reported, "Death could not have torn from Richmond a more useful and beloved citizen than was Major Lewis Ginter."

Not long after Ginter's death, the Jefferson Hotel proved to follow a similar path of misfortune as that of its creator. In 1901, fire swept through the building as a result of a defective electrical circuit. More than half of the structure and its furnishings were destroyed. Though the loss was devastating to the city, the rescue of its most famous occupant from the blaze, the statue of Thomas Jefferson by Edward V. Valentine, eventually became the rallying point for the reconstruction of the landmark. When the fire threatened the portion of the hotel in which the statue was displayed, several men, including the sculptor himself, placed mattresses around the marble figure and pushed it over. Once it was tucked safely between the cushions, the men dragged the sculpture outside and away from harm.

One hundred rooms escaped the fire with little damage and were reopened to guests in 1902. The Main Street section of the hotel, however, had been ravaged by the disaster and remained closed. The Jefferson managed to limp along in this state for a number of years until a group of Richmond millionaires came together to help restore Lewis Ginter's creation. Among them were Major James Dooley and Joseph Bryan, philanthropists following the example of their departed friend.

The Jefferson Hotel reopened in 1907 with a new, more open look thanks to architect J. Kevan Peebles, the same man who had designed the new wings for Thomas Jefferson's beloved capitol. One addition to the hotel caused great excitement among Richmonders and the guests who stayed there—the alligators in the Palm Court fountain. The reptiles attracted hundreds of curious visitors each year, but some found them by surprise, especially the alligators that were fond of leaving their regular place in the Palm Court to wander into other parts of the hotel. One incident of alligator mischief involved a clubwoman who had had a bit too much to drink and believed an alligator to be a lobby footstool. When the creature began walking back toward the fountain room, the woman

Edward V. Valentine's statue of Thomas Jefferson in the hotel's Japanese palm garden, 1903. Photo by William Henry Jackson. *Detroit Publishing Company.*

became hysterical and caused a great scene—much to the wicked delight of her fellow club members.

World War II brought more mischief to the Jefferson Hotel, but the trouble was caused by the young military recruits lodged there rather than the alligators. Because the atmosphere was constantly raucous and rowdy, hotel management decided to remove the irreplaceable stained-glass windows and skylights so they would be spared from harm. This decision would prove fortunate for future restoration of the hotel after the rough period during those early war years came to a close due to another disaster. Fire broke out again in 1944 and claimed six victims.

Much like Lewis Ginter had done, every catastrophe of the Jefferson Hotel was countered with reconstruction and new direction. Some Richmonders claimed that the site was cursed with bad luck, but most considered the hotel a continuation of the triumph and turmoil that Ginter had experienced his entire life. This bizarre cycle has continued for more than sixty years.

The Murder of Lillian Madison

*W*hy the people of Richmond so enjoy watching the fall from grace of the favored and affluent, the rest of the world may never understand. Always true to their nature, citizens of the city were fixated on every tiny detail surrounding the mysterious death of a young and pregnant governess and the shadow of suspicion that fell on her lover, an attorney fresh from law school.

Lillian Madison was a well-educated young woman who loved her work teaching. At less than five feet tall, she was very delicate and attractive. While men competed for her affection, it was her own cousin, Thomas Cluverius, who won her devotion.

Tommy and Lillian began their love affair while staying with Lillian's grandfather in the summer of 1884. The two quickly advanced their relationship and were sleeping together in secret after only a few weeks. When the time at her grandfather's house had ended, Lillian continued to meet Tommy for illicit rendezvous at hotels in Richmond. Lillian eventually found herself unwed and pregnant with her cousin's baby.

As was the typical course of action for unmarried mothers during the time, Lillian took a job in a town where she and her family were unknown to wait out the pregnancy. She moved to Bath County and found a job at Millboro. While Lillian was away, the birth of her child growing nearer and more real every day, Thomas Cluverius completed college and started his life as a lawyer. The prospect of the affair with

his cousin and their child together being the ruin of his promising future in law was something that eventually consumed his attention. Options were limited, but Tommy was finally able to convince Lillian that the best thing for both of them was to put an end to the pregnancy.

On Friday, March 13, 1885, Lillian and Tommy met in Richmond and sought out any abortionist willing to help them with their plan. The search, however, was futile. Even the most unscrupulous people they met with refused to perform the procedure because Lillian was already eight months into the pregnancy. The two talked with anyone rumored to conduct backroom operations and were seen in many different parts of the city. Witnesses placed them in bars, on streetcars and even at the nail factory on Belle Island throughout the course of the day. By nine o'clock that evening, there was still one more person to visit, or at least that was the story that Tommy told Lillian.

They took the streetcar to Main and Reservoir Streets in the bitingly cold wind and snow. The two then set off on foot to the south, headed toward the Marshall Reservoir. Sometime between 9:30 and 10:30 p.m., a man who lived near the reservoir said that he heard what sounded like

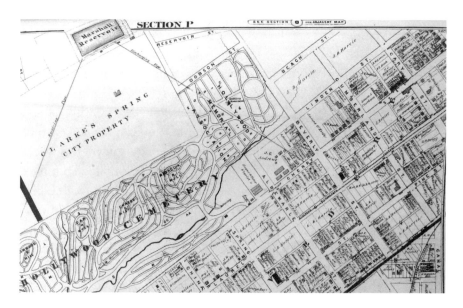

Map of the reservoir area from the time of Lillian Madison's murder. *Library of Congress, Prints and Photographs Collection.*

shouts and then a cry. He went out to investigate, but after walking some distance and not hearing anything further, he returned to the warmth of his house. Meanwhile, Lillian Madison was sinking into the still, black water—dead from a severe blow to the side of the head.

The next morning, the reservoir keeper noticed a trail in the snow leading to the edge of the reservoir, where the footprints then became erratic, like some sort of scuffle had occurred. There he saw a lady's glove on the ground and was inspecting it more closely when he noticed part of a woman's dress floating near the edge of the water. He quickly ran and alerted police.

Coroner W.H. Taylor arrived and removed the young woman's body from the reservoir, while investigators surveyed the scene for clues of what happened there the night before. The glove had been turned over as evidence and a statement taken from the neighbor about the noises he had heard in the area. Lillian's body was sent to the poorhouse on Hospital Street to be identified, while police began the search for her killer.

Detective John Wren took the case and soon found something at the crime scene very pertinent to the case—a gold watch key collected near the reservoir fence, not far from where the gravel had been disturbed by a fight.

Wren retraced Lillian's steps, starting with the purchase of her train ticket from Millboro to Richmond. He learned the details of her trip from railroad employees and talked with staff at the American Hotel about her check-in at 3:00 a.m. on Friday morning and about her behavior while there. A letter had been delivered to her by courier very early that Friday, and a reply was swiftly sent.

Lillian left the hotel about 9:00 a.m. and returned with a man in a coat and hat to retrieve her bag after dinner that evening. A short time later, the courier reappeared, complaining that the recipient of Lillian's letter could not be found. When she did not come back to the hotel that night, the manager, assuming that she had simply moved on, tore up the note and threw it in the wastebasket. Detective Wren collected the torn pieces of paper to aid his investigation. When reassembled, the note read, "I will be there as soon as possible, so do wait for me."

Detective Wren, now working with Justice Richardson at his side, determined that the next course of action in finding Lillian's killer was a thorough search of her belongings. If this were truly a crime of passion,

a key to the case would be found there. Richardson sent a telegram to the victim's employer, Mrs. Dickinson, explaining the situation. She was swift to cooperate and shipped all of Lillian's clothing and property to him in Richmond.

The day her belongings arrived and were examined, letters from her lover, Thomas Cluverius, were found. A warrant was issued for his arrest.

Tommy lived with an aunt in King and Queen County. He was found at home when local police arrived to detain him. Everyone present was shocked at the accusations made against him, as all believed that he and Lillian were simply distant cousins, nothing more. The police also discovered that Cluverius was engaged to marry a King and Queen girl, apparently having kept the relationship with Lillian a secret from her as well.

Detective Wren and Justice Richardson found records that Tommy had checked in at the Davis House Inn on Thursday, March 12, the day before Lillian's arrival in Richmond. He had previously denied visiting the city for weeks, but once the evidence was presented to him, he stopped talking completely. Mr. Vashon, the clerk at the Davis House, told officers that Cluverius was a frequent guest, staying a night or two on his visits. He confirmed that he had seen Tommy return to the inn after midnight on the night Lillian was killed. Cluverius gave no alibi.

After his arrest, Tommy was brought to the Richmond City Jail to await trial. Crowds filled the police station grounds, and citizens tried to catch a glimpse of the rich young lawyer. The public had already assumed him guilty.

Trial began and witnesses were called to testify. The first was Dr. Stratton, who explained he had been walking north on Reservoir Street that fateful Friday night when he passed a man with fair hair and a mustache, accompanied by a petite young woman fitting Lillian's description. Just as they stepped around each other, the young man blurted out, "What street is this?"

"This is Reservoir and that there is Cary," Dr. Stratton replied.

"And the time?" Cluverius asked.

"Quarter past nine o'clock."

Dr. Stratton then heard Tommy say to Lillian, "I know that fellow, but he does not know me." They continued their walk south, and Dr. Stratton to the north.

As if the doctor's testimony was not enough to place Lillian Madison and Thomas Cluverius together near the time of her death, evidence concerning the watch key found near the reservoir fence was presented. The key was of the same style and had been tooled to fit the watch collected from Tommy's personal belongings upon his arrest.

More witnesses were called who placed the two desperate lovers together on the evening of the murder. The streetcar driver testified and identified Cluverius as the man he let off with a young lady at Main and Reservoir Streets after nine o'clock that night. William Tyler, an employee of the American Hotel, swore that Cluverius was the man who had returned with Lillian to the hotel on the night of March 13 to fetch her bag. The prospects of Tommy's acquittal darkened with every witness who came forward.

The questioning of witnesses ended about 8:00 p.m. Coroner Taylor then presented details concerning Lillian's pregnancy and the savage beating and blow to the head she had received before being pushed into the reservoir. Her lungs were not filled with water when her body was examined, determining that it was the beating that killed her and not the act of drowning. Any defensive argument that Lillian Madison had died from an accident was completely implausible.

In less than an hour after the coroner's address, the trial ended. Virginia law at the time prohibited the accused man of testifying in his own defense, and the evidence presented by Detective Wren and Justice Richardson countered all of the statements Tommy's family had given in his defense. Many jurors believed the ornate watch key found at the scene of the crime to be the final stone cast against Cluverius.

After only a few minutes of deliberation, a verdict of guilty was returned. Thomas Cluverius was then sentenced to be hanged at the Richmond City Jail. Because of his keen knowledge of the law, Cluverius attempted an appeal. The move only served to delay his execution for nearly two years after Lillian's death.

On the morning of Friday, January 14, 1887, a huge crowd of morbidly curious Richmonders gathered on the hillsides of Shockoe Valley. The jail sat at the low point, nearly in the Shockoe Creek below, with the hills creating a natural amphitheatre. Cluverius was escorted to the gallows, his face bright red with emotion as the hood went over his head. A new

braided silk rope was then placed around his neck and knotted securely. At nine minutes past one o'clock, Deputy Macon dropped his handkerchief as a signal to Deputy Johnson to drop the platform. The condemned man fell, but the hanging did not go as planned.

The black silk rope stretched with the weight of Cluverius instead of swiftly breaking his neck. His feet had come within an inch of the ground. The crowd screamed and gasped at the choking and gurgling sounds coming from Tommy—his quick death had been replaced by a slow strangling.

As his feet came nearer the ground below the gallows, a deputy had the unpleasant duty of pulling up the rope on which Thomas Cluverius dangled. It took an excruciating eleven minutes at the end of that rope for Cluverius to die.

The people of Richmond felt that fate had intervened on the execution and caused the convicted killer to suffer such an agonizing death. In their own strange way, they rejoiced in the macabre justice served for the murder of Lillian Madison.

Henry Beattie and Beulah Binford

Automobiles were still quite rare in 1911, and many of Richmond's traditionalist population were hopeful for their disappearance. It was not uncommon for motorists to receive jeers or threatening shouts from those they passed. In hindsight, one could say that Henry Beattie saw this kind of harassment as more of an opportunity than an obstacle.

On the sticky night of July 18, a peculiar series of events led to one of the most sensationalized trials in the city's history. Henry, the wealthy son of a dry goods merchant, and his young wife Louise Owen Beattie decided to make a trip to a pharmacy in south Richmond after 10:00 p.m. to pick up a prescription. Though the shop was closed, Henry called up to wake the store's owner. The couple waited and talked outside while the order was filled. They climbed back into the car and drove down Midlothian Road back toward the home of Louise's uncle, from which they had departed less than an hour before.

What occurred between the couple leaving the pharmacy and their return to the Owen house is still not completely clear and without question. About midnight, the rumble of an engine and the hysterical shouts of Henry Beattie outside the home summoned its occupants out in a panic. There they found the young man covered in blood, trying to hoist his limp and unresponsive wife out of the car. "My God, they've killed Louise!" he cried.

Beattie was frantic, bouncing between sobs and choked attempts to explain the details of the tragedy. Thomas Owen made a call to the

police, and in just a few minutes, officers set out to search the area Henry Beattie had described as the scene of the crime. The coroner, Mr. Loving, arrived to examine Louise's body.

The quick reactions of police officials, the coroner and a pack of bloodhounds sent the neighborhood into a frenzy. When detectives arrived to interview Henry, they found dozens of curious spectators milling around the Owen property. Eager to find out more, several groups of thrill-seekers had already traveled up Midlothian road to glimpse the grisly scene for themselves.

Thomas Owen had been able to extract some of what happened on the fateful drive that night from Henry, and Henry relayed the events exactly to police. He said that while traveling near Providence Church Road, a man had stepped directly out in front of his car. At only fifteen miles per hour, Henry claimed that he still had to slam on the brakes to prevent running over him. The man, who was described as tall and bearded, shouted complaints about the motorcar trying to take up the whole road. That is when Henry said that he noticed the shotgun in the man's hand.

Attempting an escape, Henry leaned forward to start the car. The stranger told him that if he cranked the engine he would shoot. The clutch caused the car to lurch, and a shot was fired, striking Louise. As she fell to the floor, Henry jumped from the car and fought the gun away from the shooter, but not before receiving a sharp blow to the nose that caused him to black out. When he regained consciousness, he found the gun at his feet and the man nowhere to be found.

Henry tossed the shotgun into the back of the car and pulled Louise back onto her seat. He supported her bleeding, lifeless body with his arm around her and drove as quickly as the car could manage back to the Owen house.

Crazed and distressed, Henry asked for some whiskey, which Thomas Owen immediately sent someone to fetch. After he had calmed down slightly, Henry was made to retell his story to investigators several times, answering their questions as they arose. Within hours, a hunt was underway for a murderous bearded man. The dogs brought in from the city and neighboring counties were quite animated at the scene of the crime but frustrated police when they repeatedly failed to pick up on any

trail leading away from the road. The spark of suspicion toward Henry Beattie was then ignited.

In the days that followed the tragedy, all of Richmond hung on each word in the newspapers regarding the case. Photographs from the crime scene and of the debonair young husband helped to further sensationalize the story. The public openly voiced its own mistrust of the spoiled socialite. It seemed that all were eager to witness the fall of another of the city's elite residents.

The coroner and police investigators worked day and night to unravel the case. For every detail they uncovered, another hole was left in Henry Beattie's account of the murder. Within hours of first examining the body of Louise Owen, Coroner Loving was certain that she had been shot at very close range because the entry wound was only the size of a half-dollar, not a broad or scattered shot like one would expect from five or six feet away. The real turning point in the investigation came when police received a tip that a shotgun matching the one Beattie claimed to have tossed into the back of his car—the one that mysteriously disappeared before his return to the Owen house and was later found on the Belt Line railroad tracks— was sold to Henry Beattie's cousin Paul only a week before the murder.

Sam Stern, the owner of a local pawn shop, came forward and gave his sworn statement to police that Paul Beattie had come into his store specifically looking for a single-barreled shotgun. He said that he sold him one that was about thirty years old, not commonly used since the turn of the century but still reliable. Paul Beattie seemed pleased and paid $2.50 for the weapon. It was discovered a short while later that Paul had acquired several shells for the gun at a hardware store in his neighborhood.

When investigators knocked on Paul Beattie's door, he opened it, took one look at the stern expressions on the faces looking back and blurted out, "I did not buy it for him!" It did not take long for the nervous man to offer up a confession. In it, he explained that his cousin Henry had called and asked him to meet. Henry told Paul which type of gun he needed but did not say for what reason, and he offered to pay him a modest fee if Paul could find one for him. Henry drove them to a pawnshop on Broad Street, and there the weapon was purchased.

Paul Beattie's confession was exactly what investigators needed to place Henry under arrest. When police arrived to detain him, he showed

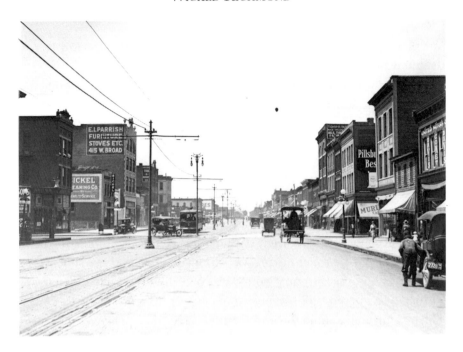

The Broad Street neighborhood in which Paul Beattie purchased the murder weapon. *National Photographs Collection, Library of Congress.*

no surprise or emotion. He was taken to the Henrico jail, where he spent the next few weeks strumming his guitar and smoking cigarettes, never professing his innocence or denying the charges placed on him.

With Henry in custody, a case against him was carefully and quickly built. In an effort to find clues in Beattie's past that would shed light on his recent actions, investigators found a State Health Department record that revealed that Henry had fathered a son two years earlier with a young girl named Beulah Binford. It was soon discovered that Beulah was not merely a ghost from Beattie's past; the two of them had been together the night before the murder of Louise Owen. Henry Beattie's defense was crumbling like a house of cards.

The first day of the trial arrived within three weeks of Beattie's arrest. Because of the local news coverage and the published announcement of the court date, spectators turned out in droves. Special streetcar lines were established just for the occasion, and each was filled to capacity. When Beattie arrived at the old courthouse, there were so many curious

onlookers that police had to push them aside to allow the prisoner and the lawyers in the case to enter the building.

Henry's face was calm, sometimes even sporting a smug grin. Upon finding a row of eager newspaper reporters as he entered the courtroom, some witnesses even said that he looked entertained.

Paul Beattie was called to the witness stand and questioned about his role in the crime. Instead of the edgy, nervous man from whom police had obtained a confession, there now sat a cold and calculating witness who dodged questions and gave open, innocent answers to others. By the time his questioning was over, Paul Beattie had somehow managed to make his purchasing the shotgun used to kill Louise Owens appear insignificant.

It was in Paul's testimony that jurors first learned of the "other woman" in the case—Beulah Binford. Henry Beattie's ongoing illicit relationship with the teen was put on display by prosecutors to help diminish his character during the trial and to show that he may have had the intention of doing away with his wife in order to reconnect with Binford.

From left: Paul Beattie, Sergeant Wrenn and Magistrate Jacobs. *George Grantham Bain Collection.*

The judge called a recess for the day and ordered the prisoner be held in the "lockbox" at the rear of the courthouse rather than be returned to the Henrico jail. The public went wild and lined up to peek into the dark behind the bars of the tired old holding cell like Beattie was some sort of carnival oddity.

The next day of the trial, the accused was called to the witness stand. Henry Beattie's testimony was so smooth and easily delivered that everyone in attendance fully expected him to leave the court a free man.

The prosecution questioned Henry about his relationship with Beulah Binford, offering the idea to jurors that his renewed connection with the "girl about town" was the reason for his wife's murder. The questioning established that Beattie had agreed to rent a flat in Richmond for Binford. He claimed that the flat was to help the girl while she sought employment in an attempt to live a respectable life, but prosecutors alluded to the possibility that Beattie set up a home for Binford in the city simply to make their affair more convenient. In fact, Beattie admitted on the stand that he and Beulah Binford had spent two days together just before the murder of his wife.

The public was enthralled with Beattie and his behavior with such a scandalous young girl. Newspaper reporters took feverish notes during his testimony and assured the people of Richmond that they would miss no revealing detail.

Henry Beattie's examination continued, and the questioning was guided next to details concerning the shotgun and its purchase. He testified that he had never commissioned Paul Beattie to purchase any weapon for him, noting that he had regular access to a number of guns in his own home, and claimed that his poor cousin was simply trying to gain monetary leverage within the family if he said anything to the contrary.

The prosecution had Henry recount the events that took place on the night of his wife's death, from the moment they left the Owen home to retrieve their prescription to Henry's return with the lifeless body of Louise. The story of the couple encountering the man on Midlothian Road was the same story he told investigators during their original inquest. The defense seemed rather pleased with Henry's recall of that night, believing that the jury would find sympathy for him, but the prosecution was preparing to finish Beattie with the trap he had inadvertently laid himself.

In a total of ten days of testimony from various witnesses, the case concluded. Special Prosecutor L.O. Wendenberg gave his closing statements, which placed particular emphasis on the inconsistencies between Henry Beattie's sworn testimony and the evidence in hand. The injury to the side of Louise Owen's face showed fault in Beattie's account that the man with the gun had fired from in front of the car, a point also weakened by the fact there was no damage to the windshield. The strongest evidence came from what Wendenberg called the "mute witness"—the clothing Henry Beattie had been wearing the night of the crime. He claimed to have held his wife up at his side while driving back to her uncle's house, but the shirt and jacket had little or no blood on them. His trousers, however, had been almost completely soaked, proving that Louise had been lying crumpled in the floor with her bleeding head on the seat.

Wendenberg explained to the jury that an innocent man would have been so affected by the events Henry claimed had happened that "every detail would have been seared into his brain." His closing statement left jurors and spectators speechless: "Let that man go free! What, let that man go free! Why, the motherhood of Virginia, the womanhood of this nation, will shudder in terror as the security of life is threatened. Let this man go free! The man who basked in the degraded sunshine of another woman while at his home a young wife nursed his new child? Gentlemen, I merely ask you in the name of justice to do your duty."

The jury deliberated for less than an hour. They returned to the cramped courtroom, and the audience fell completely silent. A few watched Henry Beattie as a slight quiver passed over his lips and anxiety grabbed hold of him. The jurors resumed their places in the jury box, and then all twelve spoke out in unison a single word: "Guilty." A symphony of news telegraphs clicked out the verdict, while Judge Watson asked the jury to determine the degree to which Beattie should be punished. They conferred, returning only a few minutes later with the verdict of murder in the first degree, a crime punishable by death.

The judge allowed Beattie's execution date to be delayed until November so that he may have time to file an appeal if he so wished. Though stoic and emotionless in front of the crowds in the courtroom, a few guards told of seeing Henry Beattie break down in tears after returning to his cell.

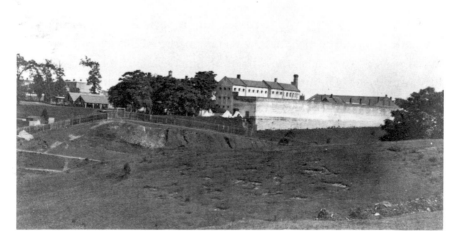

Virginia State Penitentiary near the turn of the twentieth century. *Levi & Cohen Company.*

As expected by all who learned the details of the trial, Beattie's appeal was swiftly denied by the Supreme Court of Virginia. Governor Mann proclaimed that the jury's verdict would be seen through.

Beattie was moved from the tiny, almost decrepit jail to the state penitentiary. He remained adamant about his innocence until the day before his execution. Beattie then offered a confession, lacking details of the events of the tragic night of Louise Owen's death, admitting only that he was responsible for what happened to her. The confession was transcribed by Reverend Benjamin Dennis and signed by Henry Beattie. Reverend Dennis had agreed to withhold the document from the public until after Beattie's death, as per the condemned man's request, as to somehow spare his elderly father any further suffering.

On the morning of November 24, 1911, twelve witnesses who were chosen at random by the penitentiary superintendent were escorted to the death chamber to view the last living moments of Henry Beattie. The young man maintained his stoic air even while being secured to the electric chair that would seal his fate. He was pronounced dead at 7:23 a.m.

A point from Wendenberg's closing argument of the Beattie case was demonstrated on that rainy and dreadful November day: "The law of Virginia is framed to care for the innocent, but it is also framed to make the wicked suffer."

Richmond's Smallest Menace

Long before the Civil War brought great unrest to Richmond, a different series of battles had all of its citizens on edge. The combatants were boys, some as young as four years old, who had formed some of the fiercest territorial gangs the state has known. Their battles and strategies were well organized and executed with a military sense of order, but in even the smallest of skirmishes, no bystander was safe.

The boys' weapon of choice was a rock, which was most aerodynamic when it was between the size of a marble and a golf ball. Witnesses who reported seeing some of the larger rock fights, often with one hundred or more boys on each side, tell a disturbing tale of the scene becoming so thick with thrown stones that the gangs appeared to be in a cloud of smoke. As wars over territory grew increasingly bitter, gangs adopted bricks and other more dangerous missiles. Things could get ugly very fast, and a boy without quick reflexes or who happened to be caught off-guard was likely to sustain a serious injury, as commonly occurred.

Two of the oldest and most skilled of the boy gangs were the Butchertown Cats and the Hill Cats. The term "cats" was used as an insulting term for a member of a rival group, while "boy" was the affectionate title of a comrade. The Butchertown Cats' territory was that in Shockoe Bottom, the area reaching east from Shockoe Creet at 15th Street to the foot of St. John's Church at 25th Street. Their enemies, the Hill Cats, ruled the affluent territory atop Shockoe Hill west of the creek. Topographical

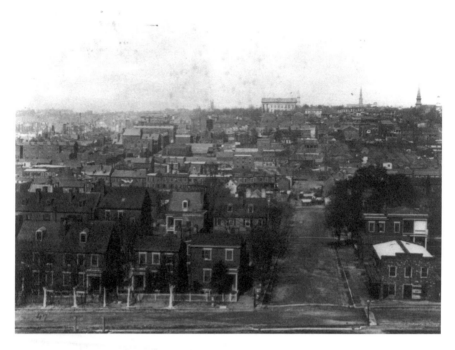

View toward Shockoe Hill from Butchertown, 1865. *Library of Congress, Prints and Photographs Collection.*

boundaries were the logical and most easily identifiable things to separate the land protected by each gang, but social and economic dividers were also a factor.

The neighborhood of Butchertown, or Shedtown as it was sometimes called, was composed of the poorer working class. The streets were lined with brothels, laundry shops, soapmakers, tanners and, as the name implied, butchers. Industry in this area gave the neighborhood its infamously unpleasant aroma. Shockoe Hill, on the other hand, was a neighborhood of wealthy lawyers, doctors and statesmen. The two rival gangs battled for decades in not only a war of territory but also of class.

The Butchertown Cats were known as little savages. Most were shoeless and unbathed and chewed tobacco or licorice like grown men. What truly earned them their rough reputations, however, were their vicious military tactics. The gang was the first reported to have employed slings to aid in their rock wars, a development that made the boys a much larger threat to the city. It was reported that a stone launched from the sling of

a Butchertown Cat could penetrate a body as deeply as a Minié ball from a soldier's gun. As the years progressed, the sling was eventually adopted by the city's many other boy gangs.

A few years after the start of the Civil War, one enormous battle between the cats took place near Rocketts. The boys were so ferocious that ladies and little girls fled the area in panic. After what seemed like an endless volley of stones were flung and dozens of boys injured, Confederate sailors from the nearby naval yard had to step in and break up the fight. Public outcry to punish these boy gangs after that day was great. Newspapers published more and more complaints about the city's growing juvenile menace each week.

The Richmond City Council, finding no other solution in dealing with the troublesome children, created a team of a dozen police officers whose sole purpose was to keep the gangs' activity in check. The handful of officers stood very little chance against the young armies of the city. When a rock battle would break out, the police team would rush in and try to capture the leaders of each side. As any respectable cat could easily outrun any officer, the police were only ever able to apprehend the slow or injured boys who lagged behind. Those captured were held at the police lockup until their parents were notified and a fine paid. When the cats scattered and their battles ended with the arrival of police, they would simply resume at another site later in the day. This cycle continued for decades.

After one fierce altercation between the Hill Cats and the Butchertown Cats, a young black boy named Jim Limber came home with a deep scalp wound and blood pouring down his face. Home for Jim was the Confederate White House, where he had been taken in and cared for by Jefferson Davis and his wife, Varina. Troubled by Jim's injury and tired of police failing to keep the gangs subdued, President Davis came down from his mansion on Shockoe Hill to address the Butchertown Cats directly. After his talk, in which he spoke to the boys respectfully and as future leaders of Virginia, the tallest and presumably oldest of the group replied, "President, we like you, we didn't want to hurt your boy, but we ain't never goin' to be friends with them Hill Cats!" Davis returned home, defeated in his attempts as peacemaker.

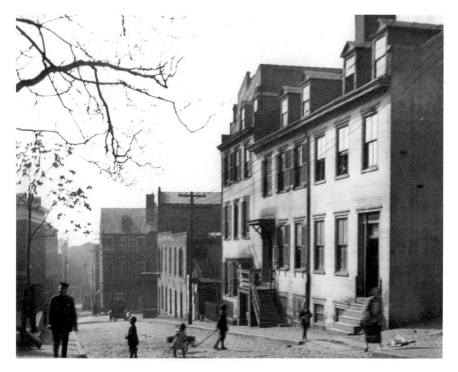

Street view in Butchertown (Mayo Street, between Ross and Franklin). *W. Palmer Gray Collection, Valentine Richmond History Center.*

The boy gangs became much more than a nuisance after the end of the war—they became a public threat. By that time, the cats had graduated from hand- and sling-thrown stones to pistols and shotguns. Obviously, along with this change in weaponry came casualties. The people of Richmond were furious, and while most tried not to get in the middle of the gang battles, some attempted to aid the police in capturing the worst of the lot. These citizens proved of great use, and the intensity of the gang violence did see some decline.

The struggle between the boy gangs continued for more than fifty years after battles between the North and the South had ended. As the first few generations of cats grew up and fathered children of their own, the subsequent generations of boy gangs were less violent, returning instead to youthful pranks and scuffles rather than deadly battles spanning entire neighborhoods. Richmond police could finally devote their full attention to new problems—illegal liquor and organized crime.

Saving the City from Itself

\mathcal{M}uch to the delight of some and the disdain of others, wickedness and immorality ran rampant in Victorian Richmond. Concern from many religious residents grew to zealous heights during the period. They feared that the city, destroyed twice in its tumultuous past, might fall again at the hands of prostitutes, drunkards and other sinners. In 1901, members of Richmond's Second Baptist Church came together and raised funds to found a group for virtuous citizens who were willing to fight back against the city's growing "illnesses." After gaining much publicity and a tremendous amount of financial support, the Anti-Saloon League of Virginia was officially founded.

The organization formed a sophisticated structure, with James Cannon, a stern Methodist bishop from Blackstone, as its head. Under Cannon's leadership, the Anti-Saloon League set out to not only clean up the loose morals of Virginia's cities but also put an end to the enterprises that supported the nuisance. Their focus was to permanently close the doors of all bars and saloons, aiming then to completely halt the booming liquor industry in Virginia.

James Cannon was quite savvy and methodical about the means he used to help the league reach its goal. The tactic that served him best was to reach out politically and win as many supporters in public office as possible. Slowly but surely, his plan proved effective. By 1909, the Anti-Saloon League had been a critical force in the approval of

Convention of the Anti-Saloon League of Virginia, 1914. Photo by Thomas Sparrow. *Library of Congress, Prints and Photographs Collection.*

legislation that had resulted in the banning of bars and saloons from eighty-six out of Virginia's one hundred counties. Later that same year, several of the remaining wet counties had elected to go dry before the league need interfere. By the start of 1910, only a few of the largest cities in the state remained wet, including the Anti-Saloon League's headquarters of Richmond.

James Cannon saw another potential opportunity for the league when he urged members to quiet their talk of temperance and instead voice their support of a dry candidate for governor. During that period, the group forged an unlikely alliance with anti-prohibition U.S. senator Thomas Staples Martin, who controlled the Democratic Party in Virginia.

The league, with its foot then wedged firmly in the political door, used its financial leverage and voter numbers to push a bill allowing Virginia residents to decide the fate of statewide prohibition. The bill was submitted and subsequently defeated in 1910 and 1912. It was not until the Virginia Anti-Saloon League, with the support of its national counterpart, launched a huge campaign to gain public support. Cannon founded the *Virginian*, a daily newspaper promoting Christian values and temperance, which propelled the league's message into thousands of homes in the state's remaining wet cities.

The Virginia Anti-Saloon League watched as its propaganda machine did its work. Other newspapers, most of which opposed a ban on alcohol, suddenly found themselves in a position in which appealing to the dry readers was the only way to remain afloat. With these messages of the social and moral dangers of alcohol reaching out daily to voters, many were swayed to change their position on the issue. This change resulted

in the election of Governor Henry C. Stuart and Lieutenant Governor J. Taylor Ellyson, both candidates who had agreed, if elected, to pass the bill for reform pushed by the league in previous years.

The bill, formally called the "Williams Enabling Act," won the House of Representatives vote by the huge majority of seventy-five to nineteen. The Virginia Senate received the bill next, and the vote was expected to be quite close. The night before the Enabling Act was opened to the Senate vote, many of the wet officials who felt that there was a possibility of the bill falling into the favor of the opposition went out for a night of drinking for good luck. They took with them a senator who was personally wet but who voted dry for his constituency. The night was one in which the drinking barely ended before sunrise. The "dry" senator was retrieved by Anti-Saloon League members the next morning and escorted to the Senate chambers, still stumbling drunk, where he cast the final vote. The outcome was a tie of twenty to twenty. As was promised before his appointment, Lieutenant Governor Ellyson cast the tiebreaking vote and passed the Williams Enabling Act. The citizens of Virginia would determine by popular election in 1916 if alcohol sales in the state would remain legal.

A propaganda campaign was launched by both the supporters and opposition of statewide prohibition. Opponents of a ban were hindered by a lack of organization and the fact that they could not boast any real benefits of alcohol. The highly structured Anti-Saloon League of Virginia, however, flooded the public with posters, leaflets and newspaper editorials urging voters to "protect the home" by banning liquor. They blamed this liquid devil for insanity, poverty, crime, shame, misery and wasted lives.

The dry campaign was going well, but it skyrocketed after the national and state Anti-Saloon Leagues formed an alliance with another extremely organized and influential group called the Ku Klux Klan. The Klan was founded during the Reconstruction era as a white retaliation against the disenfranchisement of former Confederates by the U.S. government and the introduction of black voting rights. When the federal government restored the voting rights of these former Confederates, the Klan organization, or KKK as it was commonly known, eventually dissolved.

A film entitled *The Birth of a Nation* was released in 1915 that lit the racial fires in the South once again. The film reopened old wounds about

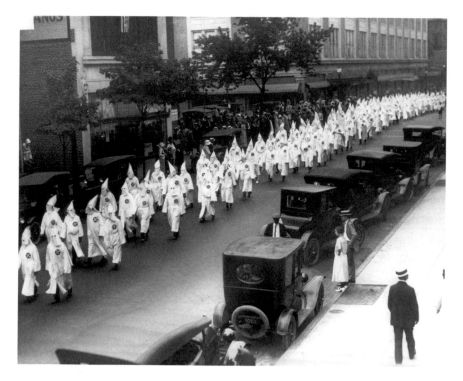

A Ku Klux Klan parade on Grace Street. *Valentine Richmond History Center.*

the Civil War and Reconstruction, especially in cities like Atlanta and Richmond. The glorified images of Klansmen fighting for "racial and moral purity" sparked a revival of the group that spread rapidly. Within a year, the Ku Klux Klan's numbers were many times greater than they had been in the wake of the Civil War, and their messages and actions were much more severe.

The Anti-Saloon League of Virginia and the Ku Klux Klan worked together to fight the alcohol industry, which they blamed for the state's "decline in morality." With the help of their new influential friends in the campaign for prohibition, the league was able to win the favor of the voting public before election day in November 1916. When the results were tallied, seventy-one of Virginia's one hundred counties had voted in favor of the ban on liquor. State legislators moved quickly to appease constituents, and a law was passed making it illegal to distribute or serve alcohol in Virginia—three years before the federal government passed its own similar caveat.

Richmond's economy received a substantial hit as a result of the prohibition law. Obviously, its saloons, bars and private clubs were shut down. Breweries and distillers were allowed to remain open, but only if the entirety of their product was shipped outside of the state. In an attempt to survive the restrictions, the city's Home Brewing Company opted to produce soft drinks instead of beer, changing its name to Home Products Company. Many other businesses followed this example, but few found the same financial success they had in their former product offerings.

During those three years between the adoption of statewide prohibition and the passing of federal laws of the same nature, Virginia law enforcement officials had their hands full trying to slow the smuggle of alcohol across state lines from Maryland, a wet state. Virginia Anti-Saloon League members and "knights" of the KKK aided officers and made humiliating public displays of all those caught trafficking liquor. By

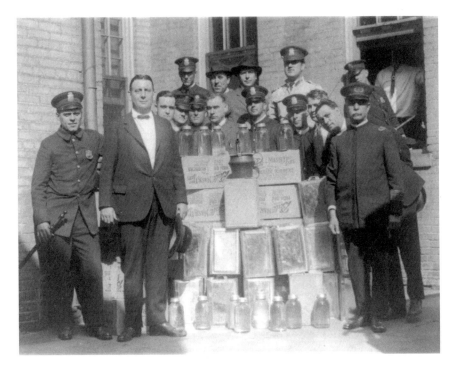

The liquor squad confiscated any large shipments of moonshine. Photo by Herbert E. French, 1922. *National Photographs Collection, Library of Congress.*

1920, U.S. Treasury officers assisted the state and local police in trying to strangle the steady flow of illegal booze into Richmond, but its citizens managed to stay one step ahead.

Richmond once again enjoyed a period of prosperity as a commercial hub for the state, but this time it was because of its willingness to distribute moonshine from the mountains to other cities in Virginia. When moving large quantities of liquor became a greater risk because of the rise in inspections from treasury officers and police, Richmonders took a variety of creative measures. Rail shipments of fruits and vegetables often contained crates of whiskey tucked away in difficult-to-reach areas of the cars. Alcohol replaced medicines in a number of carefully marked bottles, and illegal booze was even moved around in truckloads of coal.

The people of Richmond were not only fond of spirits smuggled in from the mountains but also enjoyed their "bathtub gin," a variety of homemade liquor that was literally created in a bathtub. Several

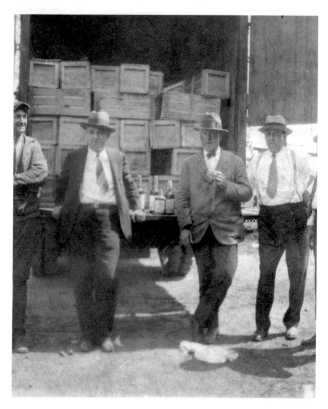

A shipment of whiskey confiscated in a tomato car. *Valentine Richmond History Center.*

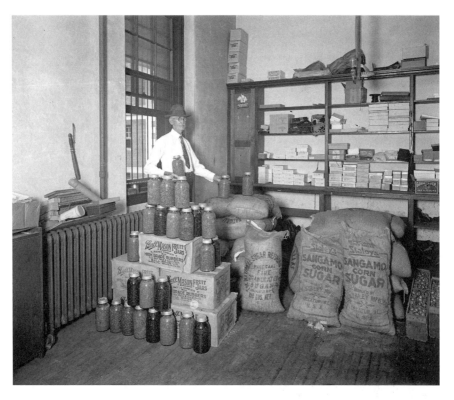

Utilization of confiscated bootleg paraphernalia, 1928. *National Photographs Collection, Library of Congress.*

entrepreneurial types opened back-porch booze operations. A few of the more popular establishments were located in the working-class neighborhoods, particularly Oregon Hill, and could be approached discreetly from the alleys. Someone in need of a drink could place his money and an empty bottle in a basket at the end of a rope. After ringing a bell or giving another designated signal, the basket would then be raised to a second-floor window, the bottle filled and the brew delivered to the buyer in minutes. These small businesses operated successfully for years because of the care taken by those involved to avoid prying eyes. This homegrown success and the creative transport of out-of-town liquor meant that there was no shortage of alcohol for Richmond during the nation's dry period.

The Anti-Saloon League of Virginia continued its efforts to help officials enforce the laws it had worked so had to push into effect. By 1928, the

league began to realize that the Richmond public was determined to get their drinks, regardless of the ramifications. Knowing that alcohol would flood into the city during the Christmas season, league members urged police to set up inspection points on all of the main roads leading into the city and encouraged random inspections of the homes of "suspicious" citizens. While these moves did succeed in confiscating thousands of gallons of the potent stuff, an estimated thirty to fifty thousand gallons still made it into the hands of consumers in Richmond that December.

The league and the Klan were exhausted in their efforts to improve the city's morality. The public had shown that it would simply result to breaking the law in order to get what it felt it deserved. These criminal acts and complicated liquor trafficking schemes gave rise to a new rash of gangs in Richmond, much like it had in the cities of Chicago, New York and Philadelphia. The local, state and federal governments soon found themselves with much more violent crime to deal with than when alcohol flowed legally.

Eventually, the war on liquor became too great a battle to fight. When prohibition laws were repealed at the national level in 1933, Richmond saw no great celebration like many other cities had enjoyed because liquor here had not been in short supply during the long years of the ban. Attitudes in the city remained much the same—except, of course, for the wave of disappointment that crashed over temperance supporters. Richmonders could now enjoy their drinks without fearing the watchful eyes of police.

It became apparent to all that a fiendish vein ran through the city that laws could not contain. The Anti-Saloon League and its political voice fell silent in Virginia. Bishop James Cannon's headlines preaching the immorality of liquor were soon replaced by those in which he was implicated in an enormous scandal concerning illegal stock market manipulations. As federal charges stacked against him in the stock case, the Anti-Saloon League's poster boy for virtue was then exposed in a scandalous extramarital affair with his secretary. It was learned that Cannon had also taken tens of thousands of dollars from the Methodist Church, funds that had been designated as campaign contributions, and kept them for himself. He was found not guilty by a court of the church, but federal court determined him guilty of violating federal election laws. Cannon's reputation was permanently scarred and a shadow was cast on the temperance movement.

The Tri-State Gang

*D*uring the rise of organized crime during the Prohibition era, Richmond became a favorite stop for gangsters traveling between New York and sunny Florida. While visiting Virginia's capital city, many of those criminals dabbled more in "business" than in pleasure. One pair of particularly violent and unpredictable men was Robert Mais and Walter Legenza, Richmond regulars with a fondness for running gun battles.

Mais, a small and wiry man with a strange, squeaky voice, and his associate Legenza were the leaders of the notorious Tri-State Gang. The two, along with dozens of other murderers, robbers and various gang thugs, ran amok in the mid-Atlantic region.

However, the group's infamy was much more widespread. Their reputation trickled into pop culture and surfaced when Batman battled the gang in a 1930s comic book, a movie was made about their exploits in 1950 called *Highway 301* and a wildly popular television series named *The Untouchables* even dedicated an episode to the terror spread by the Tri-State Gang.

Mais and Legenza had been successful at small-scale crimes like robbery and burglary for years. As their fondness for bloodshed grew along with their greed, the two devised a plan to target a delivery to the Federal Reserve Bank in Richmond. In the middle of the afternoon on March 8, 1934, the men approached a mail truck containing the bank's shipment, pried open the rear doors and shot the driver. A second postal

Form 583—Ed. 8-34

Post Office Department

POST OFFICE INSPECTOR IN CHARGE
WASHINGTON, D. C.

WANTED!

FINGERPRINT CLASSIFICATION

16	U	10	10
20	–	MI	M

Cases 64241–D—85785–D
Richmond, Va.
December 10, 1934

WALTER LEGENZA, aliases WILLIAM DAVIS, POLOCK JOE

Mail Robber and Escaped Murderer

DESCRIPTION

Age, 41 years

Height, 5 feet 4½ inches

Weight, 130 pounds

Hair, light brown

Eyes, blue

Complexion, dark

Tatoo, floral bouquet, forearm, front right

Build, small

This man was convicted and sentenced to be electrocuted for the murder of a custodian of the mails at Richmond, Va., March 8, 1934.

On September 29, 1934, he escaped from the City Jail, Richmond, Va., (accompanied by Robert Mais), after killing a police officer and wounding two others, and stealing a mail truck to further the escape. The Director of Public Safety, Richmond, Va., will pay $1,000 for the arrest, or information leading to the arrest, of this man. The Post Office Department has a standing offer of reward, not to exceed $200, for the arrest and conviction of any person stealing Government property. If this person is located, please telegraph or telephone the undersigned collect, or one of the following persons: Chief of Police, Richmond, Va.; Washington, D. C.; Baltimore, Md.; or nearest Post Office Inspector, State or City Police Station.

T. M. MILLIGAN,
Post Office Inspector in Charge,
Washington, D. C.

U. S. GOVERNMENT PRINTING OFFICE: 1934

The Post Office Department wanted poster for Walter Legenza. *Ron J. Pry Historical Collection.*

employee dropped to the floor of the truck and was spared only because the gangsters did not see him. After grabbing the enormous mailbags, Mais and Legenza sped away, leaving scores of terrified witnesses.

U.S. postal inspectors did not treat the murder lightly. Bulletins were sent to all neighboring states, and within hours, every police officer on the East Coast was on the lookout for the fugitives.

The gangsters believed that they had pulled off the greatest crime of their lives, but the celebration was short-lived. When the two stopped to inspect their loot, they found only canceled checks and other bank documents inside the Federal Reserve sacks.

Investigators were put on the trail of the men when a tip came in a few weeks later from Leonora Fontaine, former girlfriend of Robert Mais. The statement she gave police regarding the gangsters' involvement in the Richmond robbery and murder was taken at her hospital bedside in Philadelphia. Thinking that their women knew too much, the duo killed Walter Legenza's girlfriend first and then shot Leonora multiple times and left her for dead. When Mais and Legenza heard that she was still alive and was talking to police, they sent a hired gun to kill her while she was still immobilized from her wounds. After failing twice to finish the job, Mais killed the hitman. The gangsters were still determined to silence Leonora one way or another. They attempted to bomb Delaware County Hospital, but the plan was found out and the explosives were never detonated. Leonora was moved to a hospital in Washington, D.C., and placed under federal protection.

Mais and Legenza did not rest knowing that the woman who knew so many details of their crimes was now a guest of the Feds, so they had to keep moving. The botched bombing prompted their relocation to Baltimore, where they settled into a rented house in a peaceful neighborhood. These quiet surroundings were not the sort to which the criminals were accustomed, and as a result they stood out and quickly drew suspicion.

The men came and went after dark and had frequent visitors at the rental house. Neighbors, while feeling that something was not quite normal about the newcomers, had no idea that the two were recruiting new members of the Tri-State Gang. Someone eventually talked to the local police, prompting one sharp officer to match Mais to his mug shot after a little surveillance. When police were positive that Mais and Legenza were at the house, a group of patrolmen made the mistake of trying to arrest them as they were leaving home on the evening of June 4, 1934.

The neighborhood was shocked as a shootout ensued, both sides firing wildly with revolvers and machine guns. Mais took six shots to the stomach and lost the ability to fight. Legenza tried to get away in his car while still exchanging fire with the officers. Either too distracted by the battle to drive or because the vehicle was damaged so badly by bullets, Legenza ultimately crashed into the cars of backup officers on their way to help capture him.

He jumped from his vehicle uninjured and ran back to the house, where the relentless machine gun fire of police caused him to surrender.

Mais had luck on his side and managed to recover from the gunshot wounds to his abdomen. By August, the two were sent to Virginia, where sentencing for their crime would be more severe than in federal court. They were indicted by the state for the murder of the driver of the mail truck. A verdict of guilty was issued, and the two awaited their appointment with Virginia's electric chair at the Richmond City Jail instead of at the crowded state penitentiary. Though Mais and Legenza were quite well known, possibly even feared, the jail took no special precautions in guarding them.

Less than a month after being sentenced to death, Mais's mother visited her incarcerated son and brought him a roasted turkey to help him "get back his strength." Guards allowed it but failed to search the gift. If they had, they would have discovered the two guns Mrs. Mais had hidden inside it. On Sunday, September 29, 1934, Mais and Legenza used the smuggled pistols to escape. They shot and killed a police officer, William Toot, before taking to the city streets and firing wildly, reloading when they could. The pair stole a mail truck and made their getaway, laughing all the while at their successful breakout.

Mais and Legenza stepped up their crimes after their daring prison escape. One of the first things they managed was the kidnapping of another gang boss in Philadelphia. After exchanging him for $50,000 in ransom money, they hit a military weapons storage site in Norristown, Pennsylvania. There they came away with a truckload of rifles, pistols and ammunition. The men appeared to be forming an unstoppable army, and police and federal officials became much more cautious in their tracking and attempted capture.

Though they had successfully avoided arrest in the past, thanks to running gun battles and lucky getaways, an end to their crime spree was near. Events leading to their final capture were set in motion by a nine-year-old girl in Philadelphia. The girl mentioned to a friend that she was afraid to go home because some friends of her mother were staying for a while and they had lots of guns. Her friend explained the situation to her parents, and the police where then notified. Only brief surveillance was needed to identify the mother's "friends" as the leaders of the Tri-State Gang.

Because the pair were obviously heavily armed after the Norristown job, police thought it best to approach the house in an armored car. Just after sunset, detectives gave the signal to the armored car that both men had not yet left the house. As soon as the massive police vehicle came around the corner, Mais and Legenza jumped into a car and sped away. Detectives raced after them and eventually pinned them down at the Wayne Junction Railroad Station.

Using the crowded station to their advantage, the gangsters fired on police, knowing that officers would not return their shots for fear of hitting bystanders. When they ran out onto the platform, police surprised the pair by firing. They dove into the crowd, where Mais was last seen helping Legenza away from the station, visibly injured. Another lucky escape had allowed them to evade police yet again.

Undercover officers learned the following January that Mais and Legenza had managed to make it to New York and that Legenza was in a hospital being treated for two broken legs, apparently the injury he sustained at the Pennsylvania rail station. Police checked on each patient in all of New York's hospitals who had been admitted for leg injuries. They eventually found and arrested Legenza, this time unable to run.

Mais was picked up at a boardinghouse, bedridden because of infected gunshot wounds he received months earlier. Federal officials wasted no time in moving the men back to Richmond. Rather than take chances of these two cunning criminals repeating escape, their execution was planned and the date was set.

On the morning of February 2, 1935, Mais and Legenza received the most severe punishment justice allowed: electrocution at the Virginia State Penitentiary. When the two notorious gangsters were pronounced dead, the East Coast breathed a deep sigh of relief.

A Battle of Books

Three hundred years of progress earned Richmond a reputation as a city of fine art and literature. Many talented southerners, including Edgar Allan Poe, Edward V. Valentine, Sir Moses Ezekiel and others, were either born there or eventually came to call it home. Two of the jewels in Richmond's literary crown were James Branch Cabell and Ellen Glasgow.

James was born and raised only a few blocks from Ellen in the city's Monroe Ward district. He was sent to the best schools his family could find and set off to the College of William & Mary in the 1890s. His stay there did not last long, however, as a relationship with one of his professors fell victim to rumors of scandal. The school dismissed James on suspicion of being too intimate with a staff member only later to readmit him and allow him to complete his degree.

Ellen Glasgow was not particularly well educated by today's standards. She received basic home instruction in reading, philosophy and mathematics as a child, but Ellen took her education into her own hands as a teen and read all she had access to in her father's extensive library. Though she was quite shy, her intelligence made her a brilliant conversationalist, well liked by Richmond society.

The two writers made their climb to popularity at nearly the same time. Cabell wrote mainly romances, highly intellectual, with layers upon layers of imagery reserved for the most educated of readers. Glasgow chose instead to write about the often tumultuous lives of common people,

A signed photograph of Ellen Glasgow, circa 1900. *Library of Congress, Prints and Photographs Collection.*

particularly Virginians. While Cabell was being attacked by censors for writing "pornographic volumes," Glasgow was being chastised for portraying her state in a realistic light rather than glorifying it as many thought she should. The two, facing similar professional struggles and triumphs, naturally formed a friendship.

Their relationship grew and changed as time and careers progressed. Thousands of letters were exchanged between the two, at first purely about the business and art of writing and later to include the more personal aspects of their lives. With both authors possessing great intelligence and a propensity to debate, Cabell and Glasgow commonly argued about a variety of topics, sending their relationship into silent spells that often lasted months at a time. They would always set things right again after their tempers had cooled, but the cycle seemed destined to repeat.

Cabell's writing reached the height of its popularity during the 1920s and 1930s as Glasgow's work retained a steady following. Perhaps jealousy over this difference in their careers is what prompted James Cabell to take a few public literary stabs at his longtime friend. Cabell reviewed Glasgow's *A Certain Measure* for the *Richmond Times-Dispatch* and other papers with a uniquely condescending tone. Though readers of the review probably never picked up on some of his wordy jabs toward Glasgow's simple writing style, they were like hot irons to her. Tensions

A portrait of James Branch Cabell by Carl Van Vechten, 1935. *Library of Congress, Prints and Photographs Collection.*

between the authors increased, and eventually they grew distant. Ellen Glasgow died in 1945, but she did have more to say about Cabell in her posthumous autobiography, *The Woman Within*.

In the book, Glasgow talked about Cabell's embarrassing stay at William & Mary and then reopened another of his old wounds. Rumors about Cabell had flown nearly fifty years earlier speculating that he may have been involved in the murder of a wealthy Richmonder named John Scott. Scott was thought to be having an affair with James Cabell's mother, and the public suspected the young man of wrongdoing. Though no legal trouble ever came to him in the wake of Scott's murder, the whispers and stares of people in the streets were burdens he was barely able to endure. The fact that Ellen Glasgow had put this event back in the minds of readers, especially in his hometown, infuriated him.

Cabell managed to have the last word when his final insult of Glasgow's work was published in 1955. In his *As I Remember It*, he said, "I did not ever encounter, of course, quite the personage whom she depicted in Ellen Glasgow's autobiography, that beautiful and wise volume which contains a large deal of her very best fiction."

James Branch Cabell saw his career wane and eventually come to a near standstill. Readers had moved on from his heavy, ornamented writing to cleaner and simpler styles like that of his former friend. Cabell died in 1958.

The Great
Schwartzchild Heist

*R*ichmond has long been a magnet for industrialists and opportunists. Three men who set their sights on a local jewelry store in 1949 were very similar in their careful career planning to the tobacco moguls of the previous century. One major difference, however, was in the legality of their plans.

On Friday morning, February 10, 1949, Robert Pinkerman made a trip to Schwartzchild Brothers Jewelry on Broad Street and claimed that he was in search of a diamond engagement ring. After the clerk had assisted him for some time and had shown him dozens of rings, Pinkerman explained that he had very recently undergone kidney surgery and asked permission to use the store's restroom. The clerk directed him to the second floor, not knowing that this innocent trip to the men's room was actually the first step in a meticulously arranged heist.

On the second floor, Pinkerman noted the size and location of a skylight leading to the store's roof. After using the men's room, he returned to the sales floor and informed the clerk that he was unable to decide about a ring and would need to return the following day with his fiancée.

Pinkerman had seen all he needed to see at the jewelry store that afternoon. He relayed the information to his two partners, William Flowers and "Old Man" William Bostlemann. While he had been assessing the layout of Schwartzchild, Bostlemann was in a neighboring dentist's office admiring the view from the second floor. Knowing that getting into the

dentist's office would be many times easier than the jewelry store, the three set about their scheme to use the office's second-story windows to get onto the roof next door. The skylight was the best point of entry for the Schwartzchild's shop, as it would not attract attention from cars and pedestrians passing by.

The next morning, Bostlemann and Pinkerton drove to a local welding supply company and bought a small tank of oxygen and one of acetylene. When the salesman asked why they were interested in such small tanks, not typical of his regular clientele, Pinkerton answered that they intended to open a second-hand jewelry business. Realizing that their purchase had already drawn unwelcome attention, they provided the alias "Dr. E. Jamison" for the sales ticket, a name often used by their other accomplice, William Flowers.

Sometime after 5:30 p.m. on Saturday and before daybreak on Sunday (none would later disclose the exact time), Pinkerton climbed the fire escape of a building two doors down from the jewelry store. He then crossed the roof and entered the dentist's office through a window while his friends pulled a car to the front door. After unlocking the office from the inside, Pinkerton helped unload the group's tools and equipment and carry it up to the Schwartzchild's roof.

The car was moved to a nearby garage, and the three set about their plot. One broke the glass in the jewelry store skylight, and a knotted rope was secured to the frame. They lowered in their gas tanks and tool bag before climbing down to put Bostlemann to work opening the safe.

A tent was made with a heavy tarp so that Bostlemann's work with the torch would not cast a suspicious glare through the small windows onto Broad Street. After what investigators surmised to be hours of cutting, a hole was created. Bostlemann's fine touch had carefully avoided the safe's burglar alarm and built-in tear gas triggers, leaving the men an opening just large enough to reach inside and grab all they could carry. In total, their heist was worth well over $200,000 in gold and jewels, a bounty that excited the men so much that they left behind their gas tanks and tarpaulin.

The crime was discovered the following Monday morning. With nearly a day or more between the theft and its discovery, chances of finding and capturing the criminals were greatly reduced. Richmond police, with the

help of the Federal Bureau of Investigation (FBI), quickly went to work tracking down the supplier of the oxygen and acetylene tanks found at the scene. After interviewing the welding supply salesman and noting descriptions of the two men who made the purchase, they immediately set about searching their databases for the name used on the sales ticket. It did not take long for them to pick up on a trail.

The tarp left at Schwartzchild's was traced to a department store in Lexington, Kentucky, helping investigators determine that they were working with interstate criminals. The FBI took the lead in the search and began cross-checking the names of known burglars and jewel thieves with the alias from the welding supply company. The whereabouts of the most likely suspects were being established when they received a tip that "Howard Baker and Robert Pinkerman of Kansas City, Missouri, had been in on the Schwartzchild burglary." A few questions asked around Kansas City revealed that "Howard Baker" was an assumed name used by William Flowers.

Flowers was wanted in connection with a burglary in California in which he fired several shots at police. The outstanding warrant allowed the FBI to arrest him. No mention was made about the Schwartzchild heist, but when he asked officers to take him to his bank deposit box to retrieve money for bail, he was caught with the evidence in hand. In addition to the huge, 1.5-carat diamond he wore on his finger, the safe-deposit box held eleven pieces of jewelry later identified by the stock numbers etched inside them as part of the Richmond loot.

Flowers adamantly denied any involvement with the crime and claimed that he had not been in Virginia recently. He gave up the argument when FBI officials produced a Richmond parking ticket issued to Pennsylvania license number 49-UE-8, a plate found in the trunk of Flowers's car at the time of his arrest.

The parking ticket search also proved productive with the discovery that a car registered to a "Monte Bostlemann" with Missouri plates had been parked in the same garage on the same date. The FBI knew the name Bostlemann well—a known associate of Flowers's, he had played a part in dozens of burglaries, holdups, bank robberies and safe crackings across the country. The two men had served time together in a Colorado prison, where they were often guarded by a man named "Doc Jameson,"

the same name as the alias given in the purchase of the oxygen and acetylene tanks in Richmond.

Pinkerman was eventually connected to the case when FBI investigators combed through all of the city's hotel registration cards around the date of the crime. Handwriting experts matched the signature of "P. Howard and L. Roberts, Acme Brass, Erie, Pa." to the pen of the known criminal. Once a link was made, two employees of the jewelry store identified Pinkerman from his photo as the man who had shopped there the day before the break-in. He was tracked to a hideout in Kansas City and arrested.

The three men were charged by a federal grand jury in Richmond with conspiracy to transport stolen property across state lines. The State of Virginia followed soon after with indictments of grand larceny and breaking and entering. Federal marshals quickly turned over the prisoners to Virginia for prosecution, as the interstate transport charges carried a penalty of only five years in prison while the state's charges were punishable by twenty years.

Evidence against Pinkerton and his accomplices was hardly circumstantial. A friend of the trio, John H. Gould, was arrested in North Carolina soon after their own capture, and in his possession were burglary tools used in the Schwartzchild job. In the bundle was an unusual pry bar with notches in the blade and a right-angle bend that matched the marks left on a door in the dentist's office that had given them access to the jewelry store roof. Gould signed a sworn statement that the tools had all been borrowed from William Flowers and that the pry bar was Flowers's own design. The FBI also learned from Gould that Pinkerman and Flowers had bragged about the biggest jewelry "score" they had ever been part of at Richmond.

With the amount of evidence stacked against each man at the time of their arrests, the outlook at trial was not a positive one. Flowers was hit hardest by the jury and received the maximum sentence of twenty years at the state penitentiary. Pinkerman pled guilty to the charges and struck a deal with Virginia prosecutors to serve a term of eight years. Finally, "Old Man" Bostlemann, whose first appearance in court had ended in a mistrial, received a sentence of only four years for his critical role in the crime.

As could be expected, only a portion of their impressive jewelry haul was ever recovered. The *Richmond-Times Dispatch* reported that "an itemized list of the stolen jewelry was so long that it took an hour and forty-five minutes to relay it on a teletype to other law enforcement offices throughout the country." The list, composed of more than twenty pages, gave detailed descriptions of the still missing 579 diamond rings, 500 gems and more than 100 watches.

Bibliography

Barbeito, Felix. *Particulars of the Horrid and Atrocious Murders Committed on Board the Brig Crawford*. New York: E.M. Murden and A. Ming Jr., 1827.

Bridges, Peter. *Pen of Fire: John Moncure Daniel*. Kent, OH: Kent State University Press, 2002.

Chadwick, Bruce. *I Am Murdered: George Wythe, Thomas Jefferson, and the Killing that Shocked a New Nation*. Hoboken, NJ: John Wiley & Sons, 2009.

Clasen, Nancy Jean. "Elizabeth Louise Van Lew, Civil War Unionist and Abolitionist: Leader of the Richmond Union Underground." Thesis, Mankato State Univeristy, 1978.

Cullen, Charles. *The Papers of John Marshall, Correspondence and Papers*. Vol. 2. *July 1788–December 1795*. Chapel Hill: University of North Carolina Press, 1977.

Deitz Printing Co. *History of Richmond*. Richmond, VA: Dietz Printing Co., 1933.

Early, Malcom T. "Survey Report: Site of Duel: 1936 Apr. 18." Richmond: Virginia WPA Historical Inventory Project, 1936.

A Full and Complete History of the Great Beattie Case. Baltimore, MD: Pheonix Publishing Co, 1911.

Hohner, Robert A. "Prohibition Comes to Virginia: The Referendum of 1914." *Virginia Magazine of History and Biography,* issue 75 (1967).

James, G. Watson. *The Famous Cluverius—Lillian Madison Murder Case.* Richmond: Virginia State Police, 1953.

Kierner, Cynthia. *Scandal at Bizarre: Rumor and Reputation in Jefferson's America.* Charlottesville: University of Virginia Press, 2004.

Martin, Margaret C. "Virginia Party Politics and Texas Annexation." Report #98-032. Williamsburg, VA: College of William & Mary, 1997.

Minor, Lucian. *Reasons for Abolishing the Liquor Traffic.* Richmond, VA: H.K. Ellyson, 1853.

New York Times. "Beattie Confessed; Died Like a Stoic." November 25, 1911.

Pry, Ron J. "The Tri-State Gang." *United States Postal Inspection Service Bulletin* (October 2003).

Richmond Daily Dispatch. "The Richmond Spy—How Miss Van Lew and Other Richmond Citizens Aided General Grant." July 17, 1883.

Richmond Daily Times. "Death Penalty the Last Sad Act in the Reservoir Tragedy." January 15, 1887.

Richmond News Leader. "Liquor Aplenty in 'Dry' Era." December 9, 1958.

Richmond Times-Dispatch. "East End 'Cats' Raise a Bill Yell." November 25, 1910.

———. "Lurid Tale of Pirates, Murder, and Weird Trial Bared Here." April 23, 1934.

Shenandoah Herald. "A Terrible Tragedy." March 27, 1885.

Standard, Mary Newton. *Richmond, Its People and Its Story.* Philadelphia, PA: J.P. Lippincott Company, 1923.

Trotti, Michael Ayers. "Murder Made Real." *Virginia Magazine of History and Biography* 3, no. 4 (2003).

Varon, Elizabeth R. *Southern Lady, Yankee Spy: The True Story of Elizabeth Van Lew, a Union Agent in the Heart of the Confederacy.* New York: Oxford University Press, 2003.

About the Author

*B*eth Brown is a writer, artist and hobby historian who combines those interests to create a diverse mix of books and visual pieces. Her other works include *Haunted Plantations of Virginia*, a Library of Virginia Literary Award Finalist. Beth is a seventh-generation Richmonder and hopes to someday see electric streetcars return to the city.

Visit us at
www.historypress.net